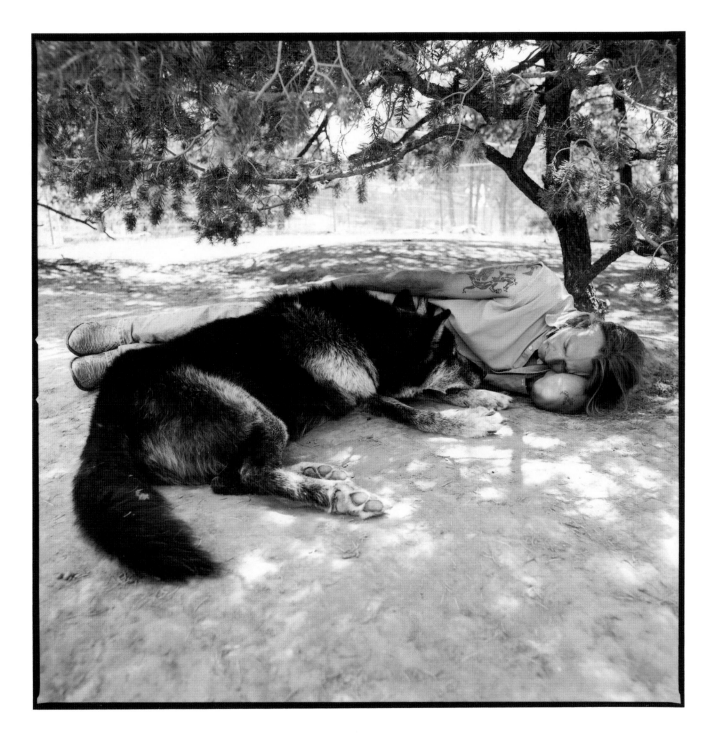

PEOPLE I SLEEP WITH

PEOPLE I SLEEP WITH

Jill Fineberg

TEN SPEED PRESS
Berkeley | Toronto

�🔟

Ten Speed Press
P.O. Box 7123
Berkeley, California 94707
www.tenspeed.com

Distributed in Australia by Simon and Schuster Australia, in Canada by Ten Speed Press Canada, in New Zealand by Southern Publishers Group, in South Africa by Real Books, and in the United Kingdom and Europe by Airlift Book Company.

Cover design by Lee Bearson and Nancy Austin
Interior design by Nancy Austin

Library of Congress Cataloging-in-Publication Data
Fineberg, Jill
 People I sleep with / Jill Fineberg.
 p. cm.
ISBN 1-58008-634-9
1. Photography – Animals. 2. Sleeping. 3. Animals, Health.
I.Title.
TX725.A2.R639 2004
641.68-dc22 20030298662

First printing 2004
Printed in Hong Kong

1 2 3 4 5 6 7 8 9 10 - 07 06 05 04

"poem #49" by Alvin Greenberg, from *Why We Live With Animals* (Minneapolis: Coffee House Press) 1990, is used with gracious permission from the author.

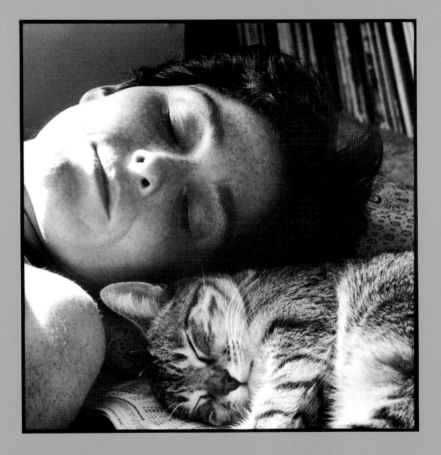

My precious best friend and nineteen-year longtime companion.
She quietly journeyed out of her sweet body May 23, 2003.

I miss you terribly and think about you always.

CONTENTS

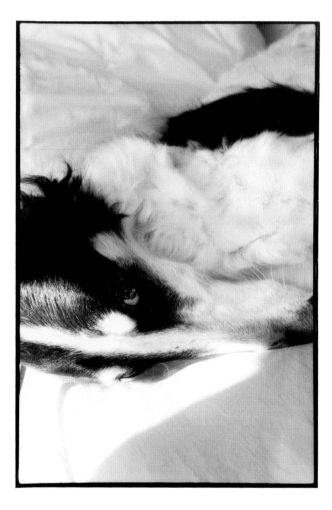

vi

vii

IN MEMORY

We risk loss every time we love. Animal companions share our lives in ways no human can. Their love for us, without exception, is one of the purest heart exchanges we can ever experience. The depth of our grief over losing our pet can trigger other unfelt losses. Sometimes it is easier to cry over a lost animal friend than a broken marriage, an unfulfilled life, or a parent's death. And so these creatures give us one more precious gift—a parting one—the opportunity to break our heart open to a deeper place inside of ourselves than we have ever been.

As Suzanne Clothier writes in *Bones Would Rain From The Sky*: "There is a cycle of love and death that shapes the lives of those who choose to travel in the company of animals. It is a cycle unlike any other. To those who have never lived through its turnings or walked its rocky path, our willingness to give our hearts with full knowledge that they will be broken seems incomprehensible. Only we know how small a price we pay for what we receive; our grief, no matter how powerful it may be, is an insufficient measure of the joy we have been given."

Ten companion animals connected to people you are about to meet died while I was creating this book. It is important to take a moment and remember the gift of their lives.

SOPHIE

ATLAS

COORS

MS. TREE

BUSTER

ROXIE

FREDERIC

SAMMY

WILLIE

SCORPIO

FOREWORD

In the fall of 1997, I made a trip to Birmingham, Alabama, to stay with my mother Mickey. We were very different people, with hugely divergent priorities in life, and completely opposite worldviews. And, of course, as is often the case, we were also a lot alike.

This particular trip home, I brought a "new" used camera to try out. Photography was one of my few interests that my mother could not only relate to, but actually praise. Her bedroom walls were covered with my photographs. So I shot a roll of 120 film of Mickey and her beloved Chihuahua, Sophie, in bed together early one cool autumn morning.

Through the lens, I saw my mother succeed brilliantly in the role of dog companion, with more purity of heart and intention than she ever accomplished with other humans. She showered Sophie with compliments, attention, patience, and with an affection I rarely experienced as her daughter.

Two years later, on October 1, 1999, my mother died. We had long before agreed that upon her death, I would bring Sophie back to my home in New Mexico and fit her into my life. Exactly two weeks after my mother died, the tiny dog walked out into my street directly in front of a pickup truck. It was a clear decision to rejoin her dear friend Mickey. I know. I was there. I held Sophie in my lap while her soul left her body.

Two blessings came from Sophie's death. The first was, prior to that moment, every time I tried to be still, or pray, or meditate, or attempted to contact the essence of my mother on the other side, I was overtaken with feelings of fear and confusion. These feelings were not mine. They were my mother's. Her death had been sudden. It felt to me as if she was unsure of where she was and how she might proceed; this was coupled with a seemingly overwhelming sense of isolation and loneliness. At the instant Sophie left her body, I sensed my mother relaxing on the other side. She seemed suddenly more able to accept and deal with her task at hand.

The second gift from Sophie was the deep grieving that finally ascended out of my belly and rushed up into my heart. The sobbing that began in me was gratefully uncontrollable. Several months earlier, my lover had left me. This was followed by the unexpected death of my best friend. Then Mickey. And now this sweet puppy.

Stunned from the collective losses, I had been unable to really grieve. It was little Sophie dying in my arms that accessed all I had been unable to feel and release. Her death cracked my heart open into a melancholy that was paradoxically laced with joy, the depth of which I had never known. For Sophie's sacrifice that day, I will always be profoundly grateful.

Six years passed. When I opened my camera bag for the first time since 1997, I found a canister of unprocessed film at the bottom of the bag. In my twenty-five-year career as a photographer, I had never left a roll of exposed film unprocessed. Curious, I took it to my lab. It was a forgotten roll I had shot of Mickey and Sophie in bed on that autumn

morning in Alabama. All these years later, the images of their love together made me cry.

I wondered how many other people in the world experienced this kind of joyous nourishment and sublime delight with their pets. So, once again, I began to take pictures for this book. Six years after the fact, I decided to finish what I had started, inspired by an elderly woman and a tiny dog with a giant heart. I felt their presence, and their encouragement, at every photo shoot.

<div align="center">❊ ❊ ❊</div>

So now you know that *People I Sleep With* is not about my intimate sexual escapades. (Believe me, you don't want to know.) It is about intimacy and those we let into our beds. And it turns out who you sleep with really does matter.

My friend, holistic veterinarian Dee Blanco, explains that in traditional Chinese medicine it is taught that when humans are in a deep sleep, their souls lie at rest in "liver energy." The expression of this energy includes safety, vulnerability, and tender sacred space. Therefore, "the bed is holy ground, best shared with our beloveds, and with those we most trust—furlined or otherwise."

A survey in *USA Today* revealed the striking statistic that 79% of pet owners allowed their animals to sleep in bed with them. And as this project unfolded, the more photographs I took of people and pets in this most intimate interaction, the more it became clear to me that our animal companions are here not only to keep us company, but to teach us about diversity. Just look through these pages: dogs and cats, of course, and a snake, a pig, a lion, horses, donkeys, birds, bunnies, a gecko, a guinea pig, a scorpion. We accept their variety, their textures, their colors, their varied dispositions, and their many individual ways of relating. They lie with children, elders, white people, black people, Jews, Christians, Buddhists, gays, straights, women, men, rich and poor.

With animals we understand that the very resilience of life depends upon these differences. Myriad combinations of species drive our ecosystems to flourish. Not to mention the joy these differences mentor to us. When will we understand the same is true regarding diversity in human beings? When will we appreciate and cherish these differences instead of being frightened by them? How long until we fully open our hearts to the luscious variety and profound diversity of humanity? I challenge myself, as well as you, the reader, to capture the loving intimacy we share with our pets and expand and extend it as compassion toward those of our own kind—and to all living creatures.

Throughout this project, I met with rescue groups and visited sanctuaries where I heard shattering stories of shocking abuse, and held animals still shivering from the horrors done to them. We tend to see such incidents as extreme cases. But are they? Consider the inhumane treatment of our farm animals, the violent execution of our livestock, the expendability of our pets in animal shelters, the conditions for animals used in scientific research. We continue to wear animals, eat them, hunt them, experiment on them, hold them captive, and force them to fight or race or perform for our entertainment. There is much to reconcile personally—I think we have a lot of work to do.

I am blessed. I live in the animal-friendly community of Santa Fe. A community where, when I first began to talk about my book, friends and strangers alike couldn't wait to share their stories, their animal families, and their homes— and then put me in touch with other animal-loving folks all

over the area. A community where Tibetan monks gather to bless its animal citizens one by one (and this project!). Where every fall I join cheering crowds to watch the Desfile de los Ninõs, the Children's Pet Parade. Where a top-notch Animal Shelter never hesitates to galvanize the community when disaster strikes, whether close to home or to our neighbors. Where, as part of a fund-raising effort for a state-of-the-art, multi-million dollar performance facility, donations were accepted for the balcony seats in honor of pets instead of people. My tabby cat, Miracle Maxine, is row L, seat 3.

Did I mention I was blessed?

Maxine used to assist me in my bodywork/healing practice. She would jump up on the massage table, (only for the people of her choosing), lie on a carefully selected portion of the client's body, and proceed to purr loudly and nonstop for exactly fifteen minutes—never fourteen, never twenty-five. If the client tried to pet her, she would cease purring, descend from the table, and leave the room. It was clearly an energy transmission she offered as a gift. She was not bidding for affection or attention. What also amazed me was that Maxine was *always* impeccably accurate as to the place on the client's body she chose as her focus. With a constipated client, she draped herself across the colon region; for a skier who had split open his forehead in a fall, she lay down right against the stitches in his scalp; and with a woman whose adult son had recently passed away, Maxine lay precisely across her heart, stretched her paw up gently, touched the woman's throat, and allowed this grieving mother to cry.

I believe one of the agendas with which animals are divinely instilled is an innate ability to heal on levels we cannot yet measure. I've seen it over and over again. The feelings we reveal to, with, and about our pets are neither shameful nor silly. Our grief when an animal dies is completely appropriate. We don't need permission to adore these creatures or feel the loss when they leave us. For those who need it, there is burgeoning scientific evidence on the physical and emotional health benefits of having animals in our lives. For the rest of us for whom these benefits are already crystal clear, we should continue to trust our instincts. After all, animals never fail to trust theirs.

Animals need us and we need them. Speaking of which, excuse me while I take a nap with my little yellow tabby cat, Bamboo. He just extended his paw toward me in an enticing, elongated stretch, and I am going to join him.

Jill Fineberg
Santa Fe, New Mexico
April 10, 2004

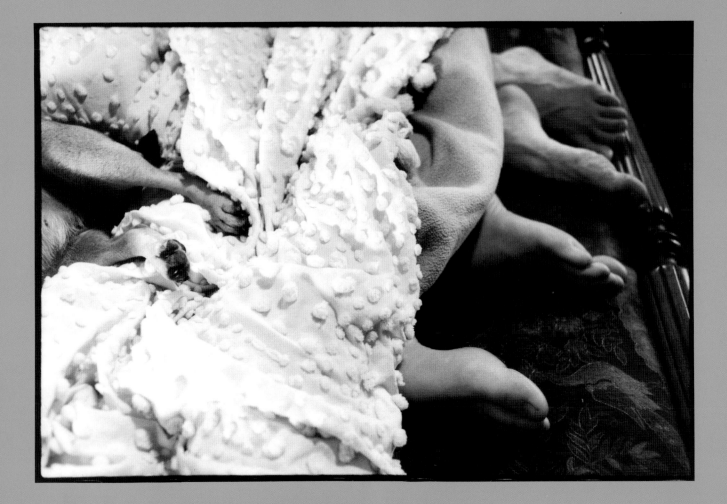

❈ ❈ ❈

God bless the inventor of sleep, the cloak of all men's thoughts,
the food that cures all hunger . . . the balancing weight that levels
the shepherd with the king and the simple with the wise.

—Miguel de Cervantes

❈ ❈ ❈

SOPHIE *with* MICKEY FINEBERG

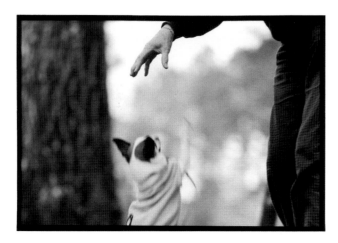

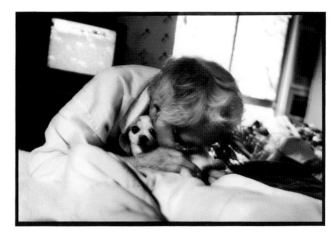

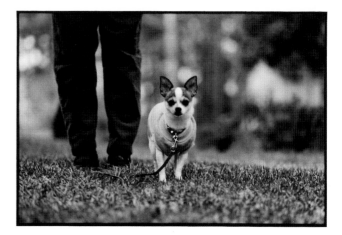

. . . many of us admit our pets into the most intimate areas of our lives. We are not in the least embarrassed when a dog sees us in the shower or overhears an argument. In this, a companion animal provides an intimacy that exceeds any we may experience with virtually any other human being, including our spouses and children. . . . A dear friend once expressed this feeling beautifully. She had been resting on her couch with her dog, and as she looked into his eyes, it seemed to her that she and he could give each other transfusions if necessary, that their very blood must be compatible.

—ELIZABETH MARSHALL THOMAS, from the Foreword to
 Between Pets and People: The Importance of Animal Companionship
 by Alan Beck & Aaron Katcher

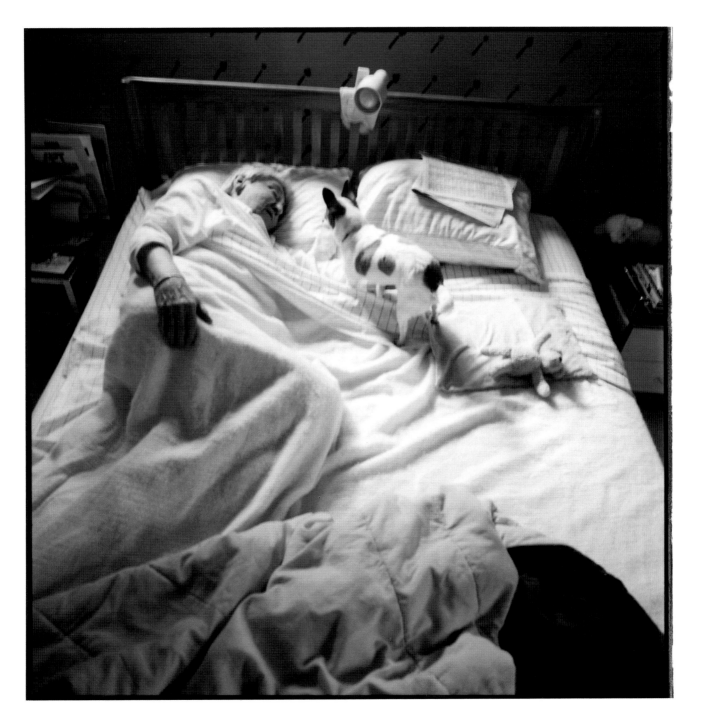

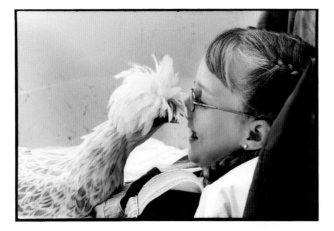

Skuttle *with* Tara Werner

4

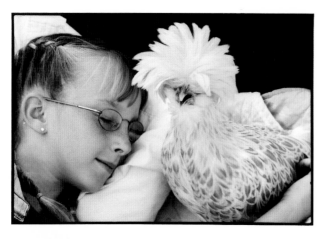

It may be surprising to think of a chicken showing trust, but it is a decision that must be made on any given day, whether to trust a specific person or other animal or not. Instinct does not help here, for the chicken's instinct is not to trust anyone who can be considered a predator. . . . The birds have learned the hard way that humans are not to be trusted; they mean them harm. To unlearn this requires a great deal of thought, based on experience.

—Jeffrey Moussaieff Masson, *The Pig Who Sang to the Moon: The Emotional World of Farm Animals*

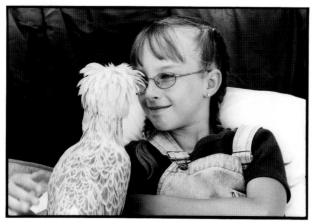

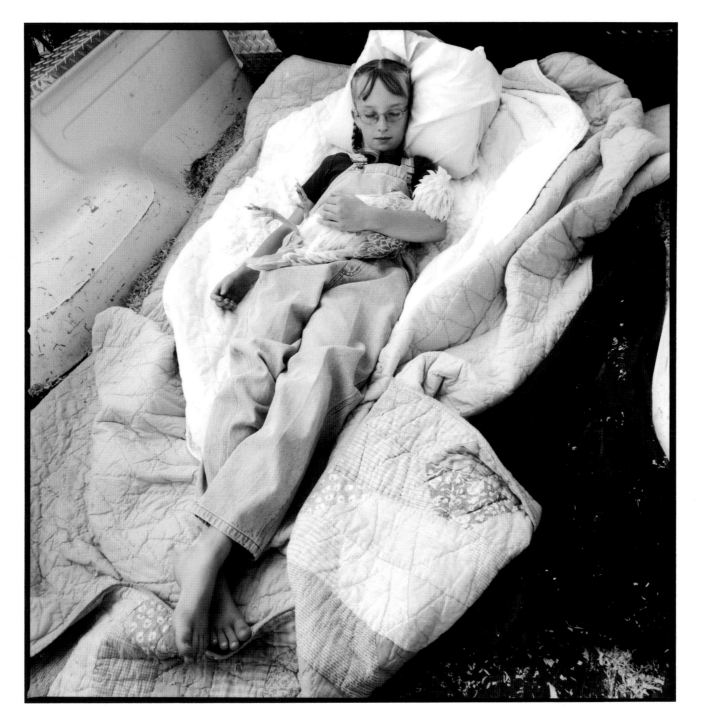

3

FRANKI & DAUPHI *with*
STEFFAN SOULE

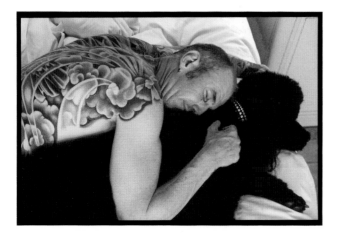

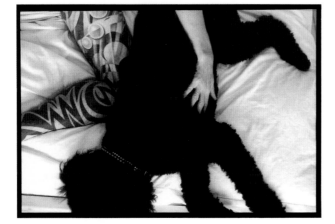

You can be sure that my dogs also love rides in the car, opportunities to chase squirrels, long walks through the woods, and foot-twitching dreams. However, you can be just as sure that these things are luxuries and not requirements for their happy lives. They are quite happy, it appears, with a day in which they accomplish little more than spending some quality time with me, getting lots of rest, and taking a couple of leisurely trips to the yard to relieve themselves.

—MATT WEINSTEIN & LUKE BARBER, *Dogs Don't Bite When*
 A Growl Will Do: What Your Dog Can Teach You About Living
 A Happy Life

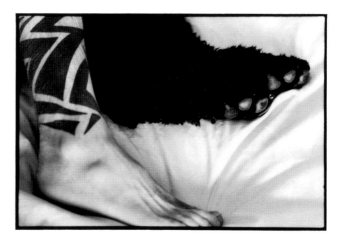

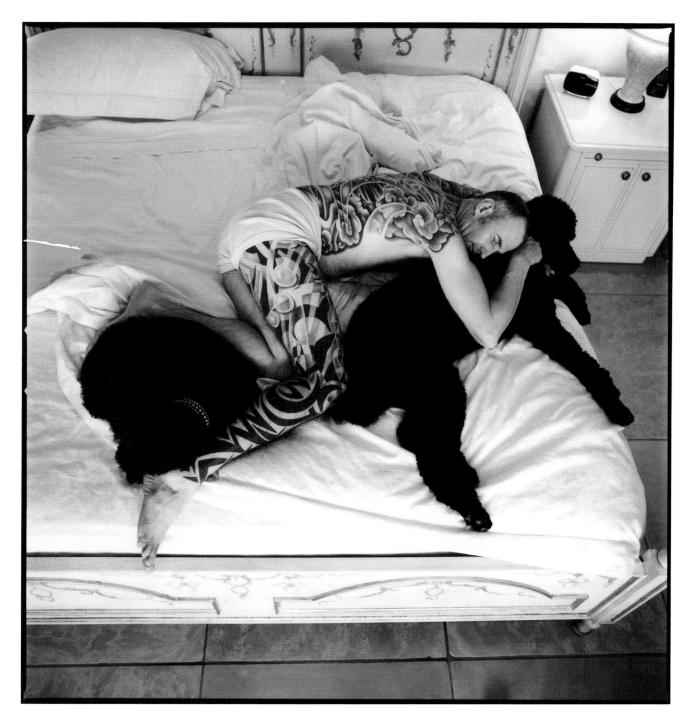

4

JAKE *with* HENRY SCHUHMACHER

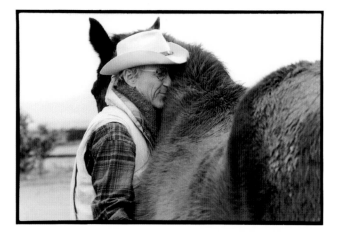

8

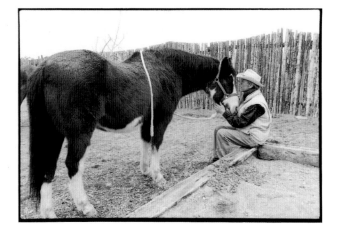

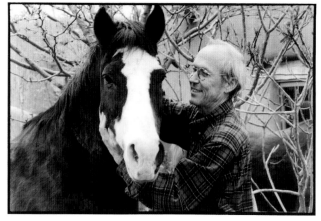

I've spent most of my life riding horses.

The rest I've just wasted.

—ANONYMOUS

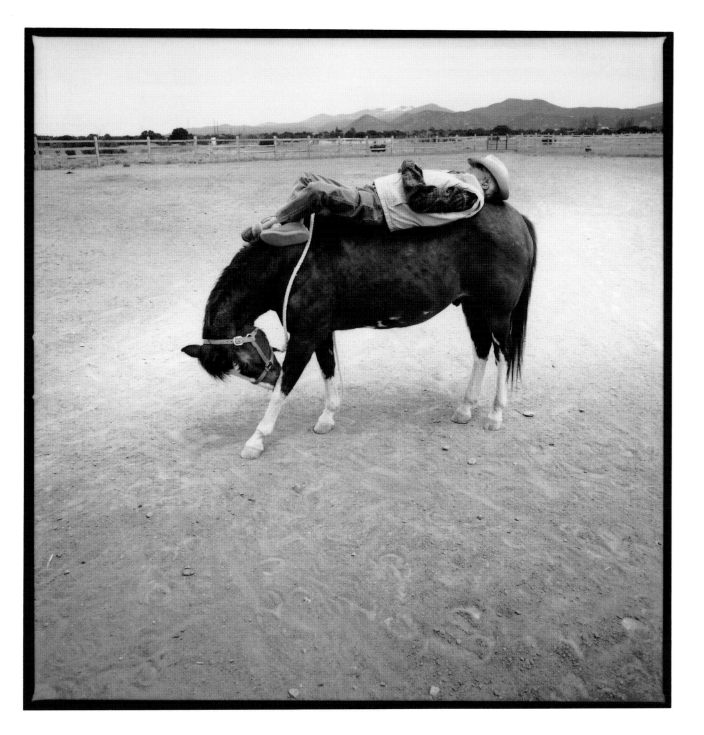

MOLLY & BRIGETTE *with*
SAM MATTHEWS

10

We get on the floor and crawl around; we say, "Goo, goo" and we play peek-a-boo. That's loving the infant. We don't lose our rights or our identity in the process. We also know from experience that if we identify with our weener dog, we sense what our weener dog wants—but at no time are we in danger of turning *into* a weener dog. When it comes to pets and infants, we understand that love doesn't hurt us or erase us . . .

—HUGH PRATHER, *Spiritual Notes to Myself*

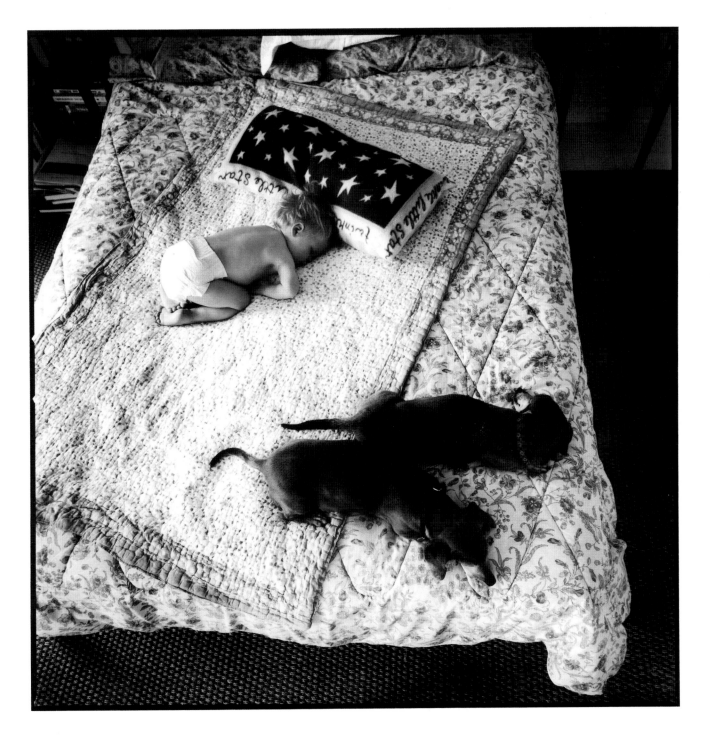

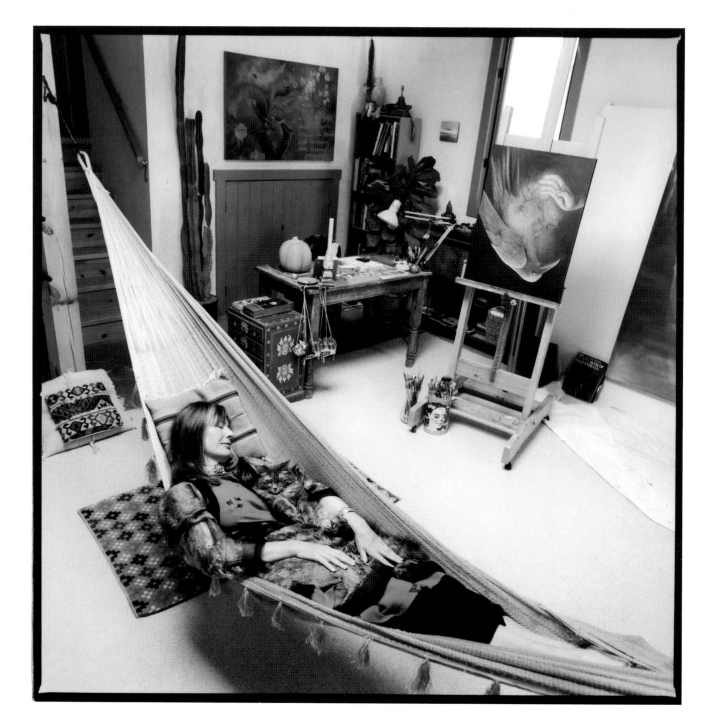

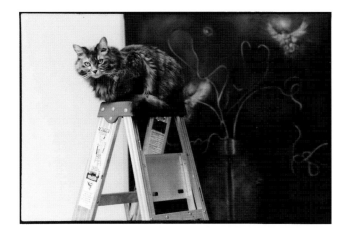

MISS KITTY *with* COLLEEN KELLEY

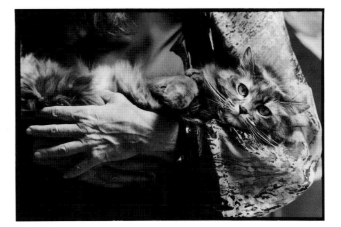

These days, I make art to praise, to remember, to subdue the demons that would devour all I love in this precious world, to evoke the luminous and to express devotion. Art making is a mediumistic endeavor and a redemptive act evoking form from the formless, creating bridges between the worlds, the invisible and the visible. The animals and birds in my work appear as beneficent visitors from the world behind the world.

—COLLEEN KELLEY

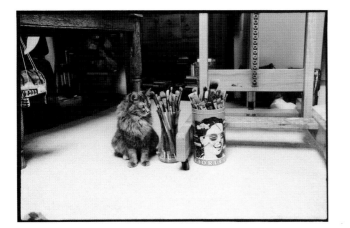

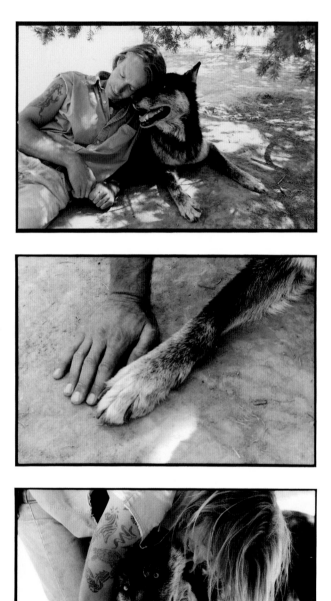

14

RAVEN *with* LEYTON COUGAR

Something mysterious happens to us when we hear the howl of a wolf, or look into the eyes of a wolf. Something familiar is calling back to us, or looking back at us. Ourselves? Yes, but we also see an other. We see something that is in us, and yet outside us, something we know, but perhaps lost, something we fear, but are drawn toward. We recognize wildness . . . our own and an other's. The "other" is very important because it is through the presence and respect for the "other" that we recognize and heal ourselves. Intuitively we understand that the assumption and attitude of dominion that led to our efforts a hundred years ago not to just control wolves but to conquer them, is the same attitude that has driven us not just to exploit our planet, but to fill it with toxic wastes, polluted skies, sewage-filled rivers, and dying forests. Ultimately it is not a choice between wolves or humans, but rather a question of how our worlds meet. Collision or confluence? Can we make room? Can we allow, endure, even revel in their wildness? Can we preserve their world, and in doing so preserve our own? Instinctively we know that what we do to the wolf, we do to ourselves, and what we do for the wolf we do for ourselves.

—RENEÉ ASKINS, "Shades of Gray" from *Intimate Nature: The Bond Between Women and Animals,* edited by Linda Hogan, Deena Metzger & Brenda Peterson

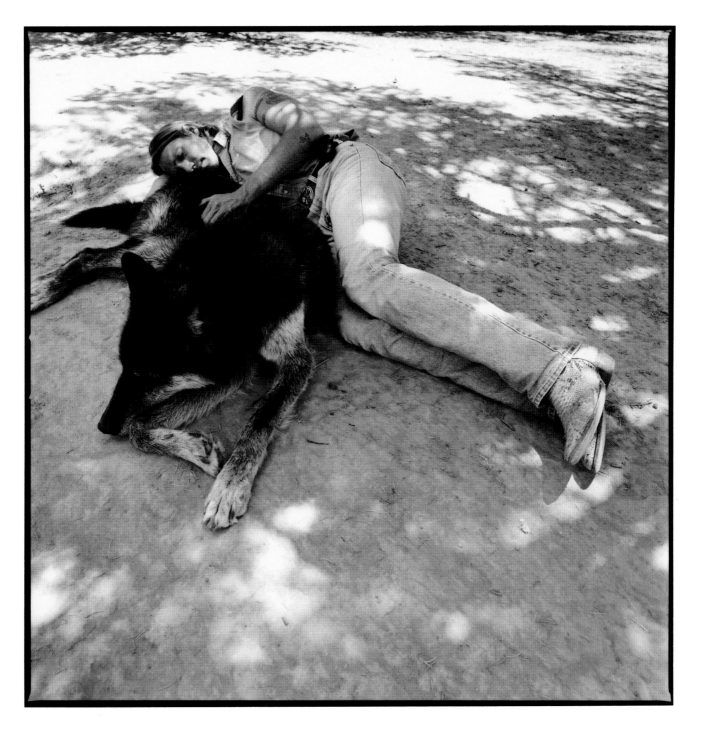

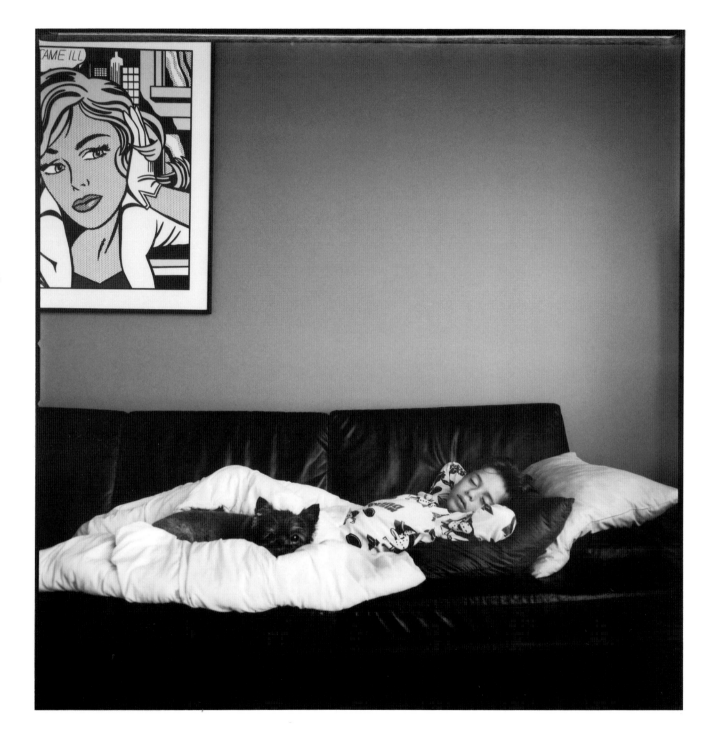

HOBBES *with* WHITAKER FINEBERG

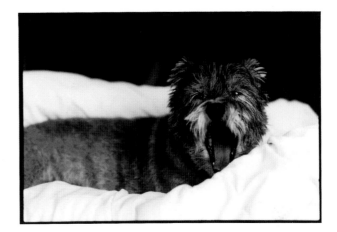

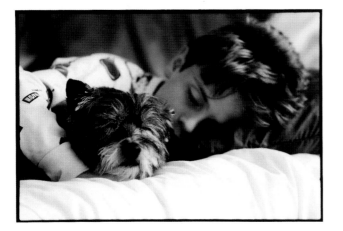

As Leslie Fielder remarked, "Children are uncertain whether they are beasts or men: little animals more like their pets than their parents."

—GAIL F. MELSON, *Why the Wild Things Are*

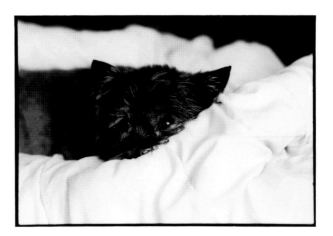

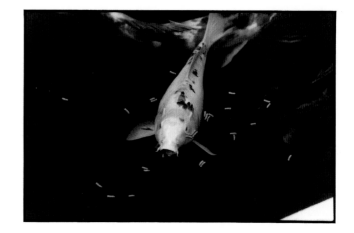

9

KOI FISH *(swimming not necessarily in this order)*: HEIDI, SHELLEY, BETTY, FRED FRIENDLY, 747, JOSEPHINE, CHEEKS, TUX, EDO, FISHER, THE SILVERMANS, BLUE MAN, BLUE BOY, SUNSET, CATHERINE THE GREAT, PETER THE GREAT, MATISSE, MIRO, SAMMY *(dog)* & TARZAN *(cat)* with SHARON BERKELO

18

We feel grateful that the animal is even there, that it lets itself be seen, that it is a power that has come into a dream, and that this visitation is a momentary restoration of Eden. Like birdsong that sounds and stops, like the squirrel tail-twitching, scurrying, and then vanished, like one slim fish breaking surface and gone—now you see it, now you don't. This is the mode of their appearance, present as an image and leaving their trace as an image.

—JAMES HILLMAN, *Dream Animals*

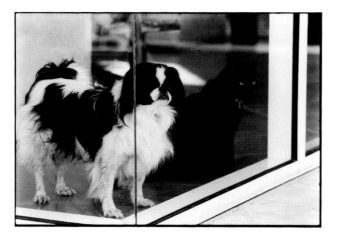

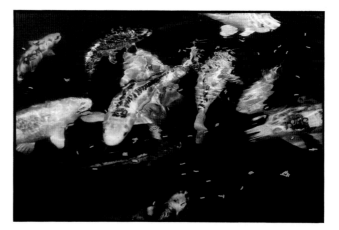

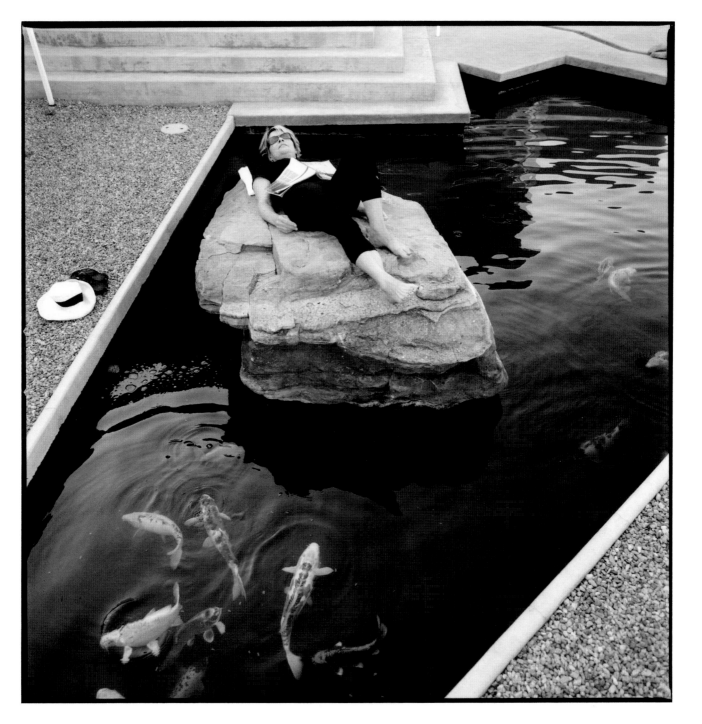

19

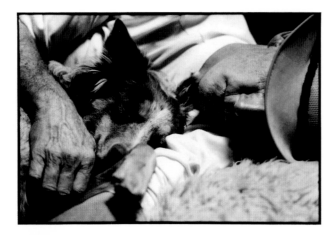

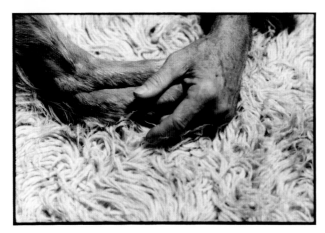

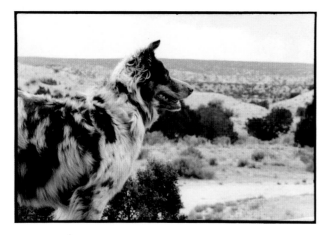

SHANNON *with* JOHN WALLACE

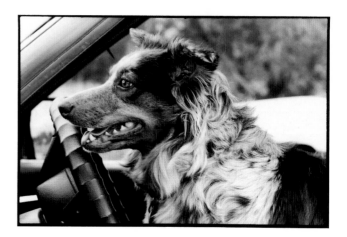

How often do you dream of animals, have visionary experiences that involve animals, follow pathways into inner space guided by animals? Animals stretch our boundaries, prompt us to ask great questions again of ourselves and of existence. And ultimately, they restore us to the fold of life. . . . Since time out of mind, we two-leggeds have performed symbolic ceremonies in order to regain our continuity with nature, masking ourselves as animals, enacting their postures, imitating their movements. Symbols and the rituals that contain them offer the possibility of aligning with nature's powers with consequences that can seem miraculous.

—JEAN HOUSTON, *Mystical Dogs*

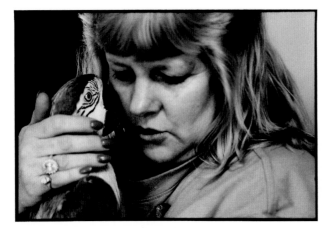

11

GUCCI, HARLEY, BEAU, SCOOTER, LEXI, MARVIN, ECHO & CHELSEA *with* PAT WRIGHT

"What is it, Polynesia," asked the Doctor, looking up from his book.

"I was just thinking," said the parrot "I was thinking about people," said Polynesia. "People make me sick. They think they're so wonderful. The world has been going on now for thousands of years, hasn't it? And the only thing in animal-language that people have learned to understand is that when a dog wags his tail he means 'I'm glad!'—It's funny, isn't it? You are the very first man to talk like us. Oh, sometimes people annoy me dreadfully—such airs they put on—talking about 'the dumb animals.' Dumb! —Huh! . . . I suppose if people ever learn to fly—like any common hedge sparrow—we shall never hear the end of it!"

"You're a wise old bird,' said the Doctor."

—HUGH LOFTING, *The Story of Doctor Doolittle*

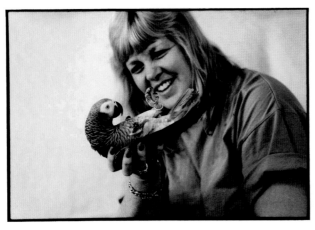

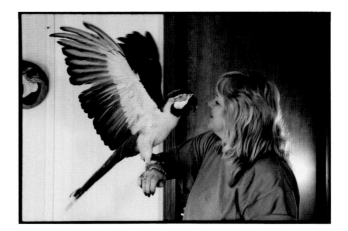

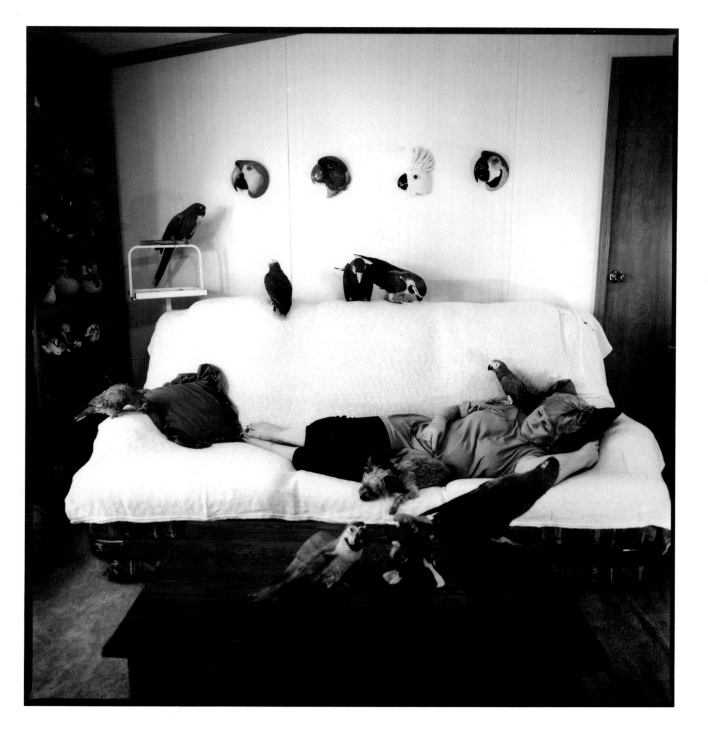

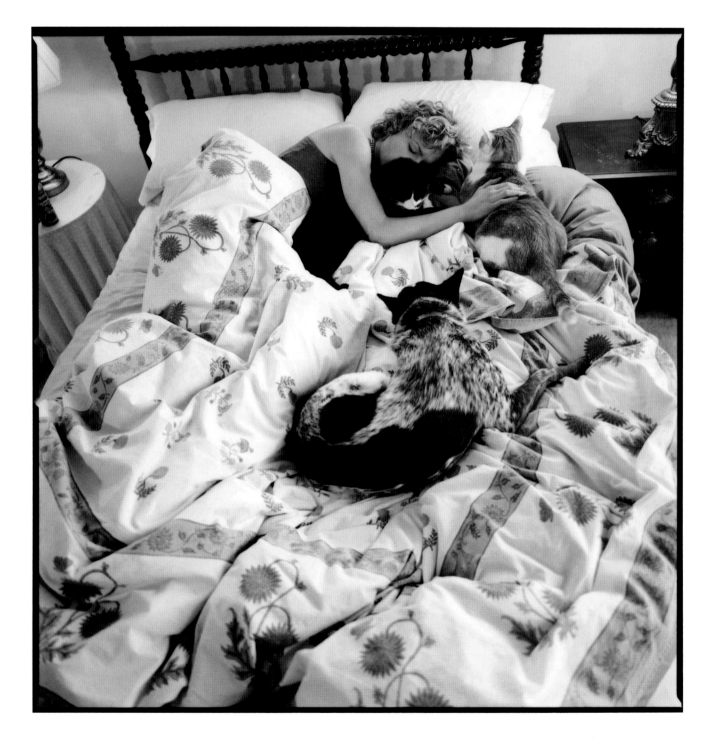

24

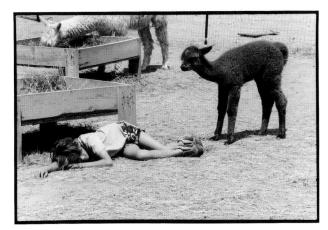

SAMOSET & IZABEL *with* GEORGIA EVANS

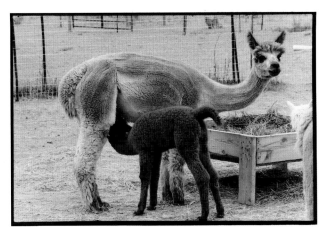

Whatever we may say about it, people have truly mutual relationships with animals and do encounter the sacred in non-human form . . . When we relate to others as spiritual beings, our experience opens into a "vertical dimension" that stretches toward infinity. Our world becomes softer and more intimate. We become confidantes—literally, those who come together with faith. And it is through faith—not the faith of creeds and dogmas, but the simple "animal faith" of resting in communion with each other and with the natural world of soil and sunlight—that we touch the divine.

—GARY KOWALSKI, *The Souls of Animals*

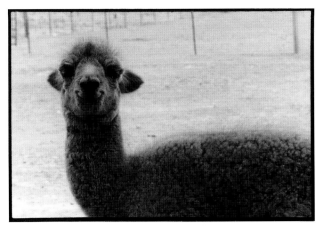

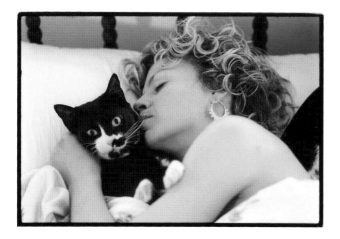

SIMON, RED & BE
with LAURA BASSETT

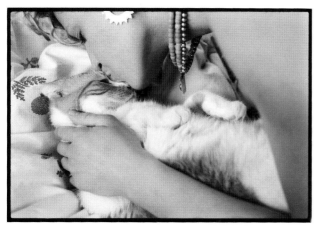

25

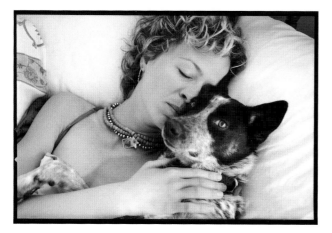

For each of us—furred, feathered, or skinned alive—the whole earth balances on the single precarious point of our own survival. In the best of times, I hold in mind the need to care for things beyond the self: poetry, humanity, grace. In other times, when it seems difficult merely to survive and be happy about it, the condition of my thought tastes as simple as this: let me be a good animal today. I've spent months at a stretch, even years, with that taste in my mouth, and have found that it serves.

—BARBARA KINGSOLVER, *High Tide in Tucson*

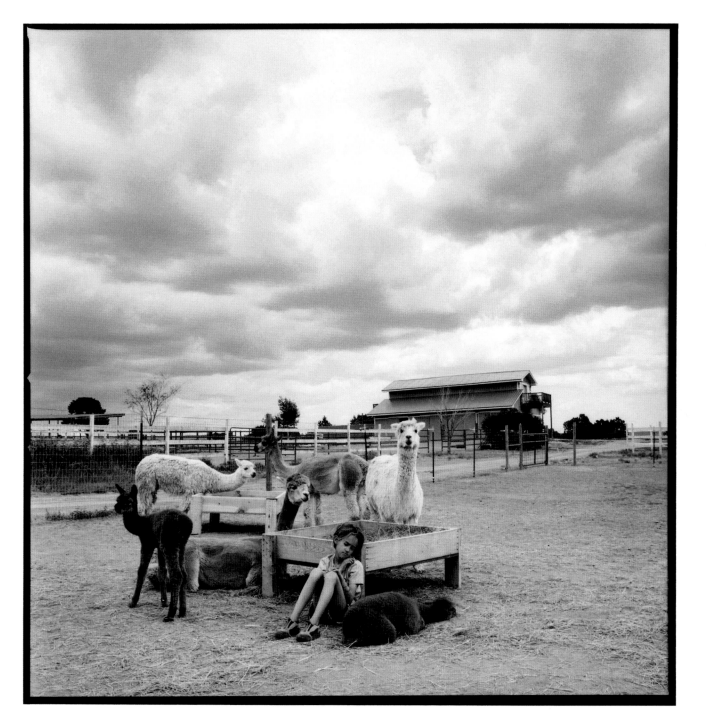

14

ARTHUR, SOLOMON, MS. TREE,
MALLORY, PETITE FOUR, AIDAN,
JAKE, GILLIE & MARIO *with*
CANDRA BRYSON

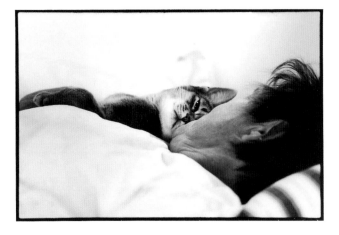

When I talk about solitude I am really talking also about making space for that intense, hungry face at the window, starved cat, starved person. It is making space to *be there.* Lately a small tabby cat has come every day and stared at me with a strange, intense look. Of course I put food out, night and morning. She is so terrified that she runs away at once when I open the door, but she comes back to eat ravenously as soon as I disappear. Yet her hunger is clearly not only for food. I long to take her in my arms and hear her purr with relief at finding shelter. Will she ever become tame enough for that, to give in to what she longs to have?

—MAY SARTON, *Journal of a Solitude*

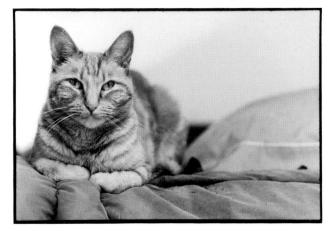

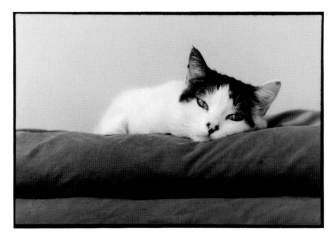

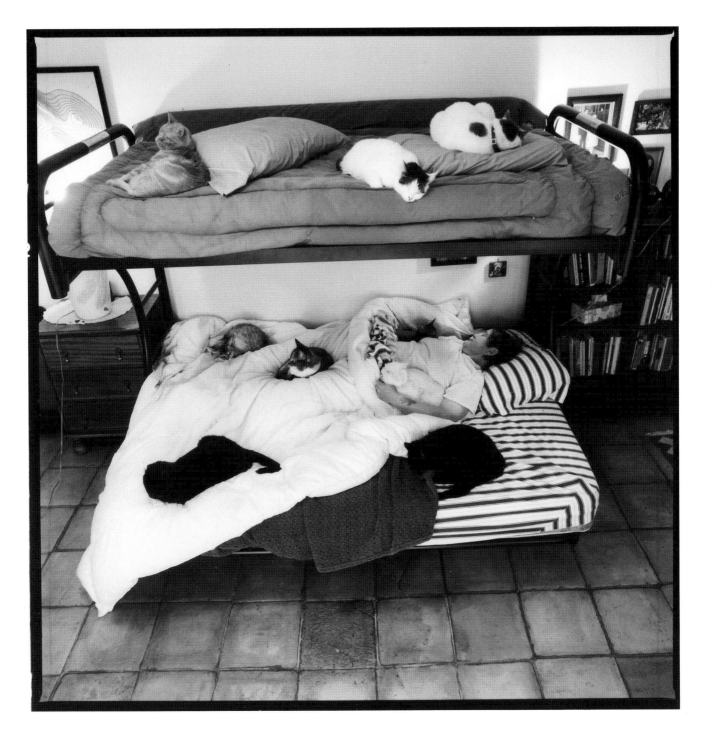

15

ASSISTANCE DOG CHIP
with JOHN CHISHOLM

30

Everything that happens to you is your teacher. The secret is
to learn to sit at the feet of your own life and be taught by it.
. . . Everything that happens is either a blessing that is also a
lesson, or a lesson that is also a blessing.

—POLLY BERRIEN BERENDS, *Coming to Life: Traveling the*
Spiritual Path in Everyday Life

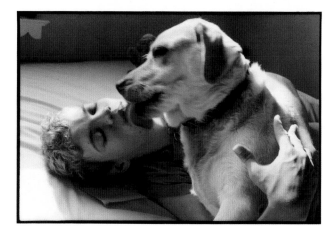

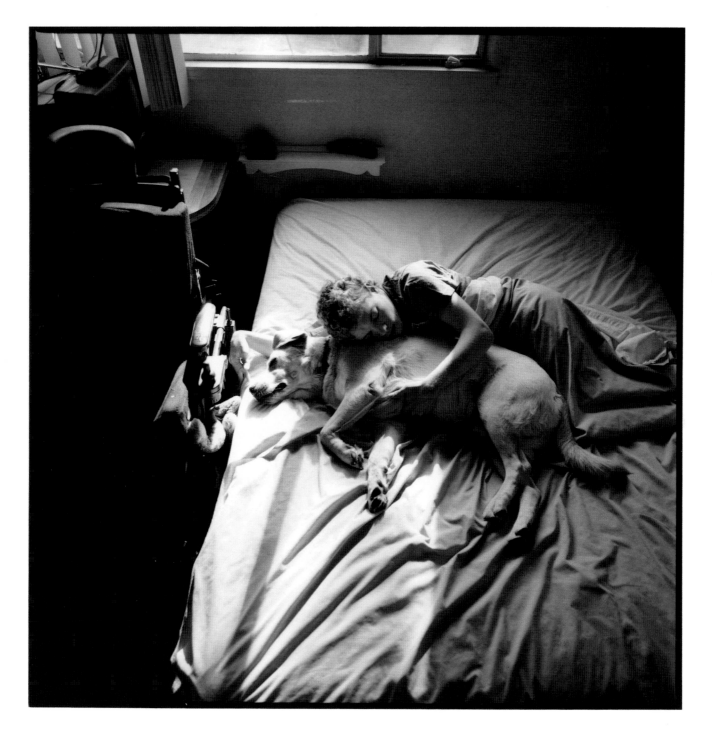

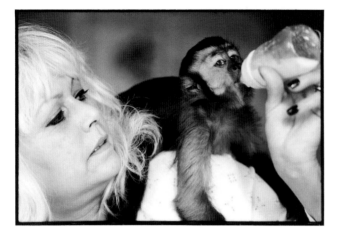

LUCI LOO *with* CYNTHIA PETTI

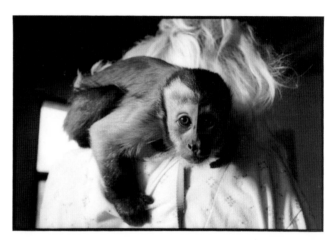

32

Life is playfulness. . . . We need to play so that we can
rediscover the magic all around us.

—FLORA COLAO

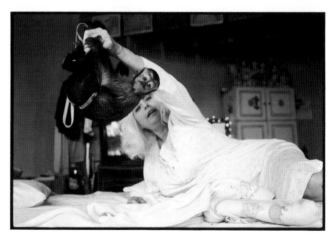

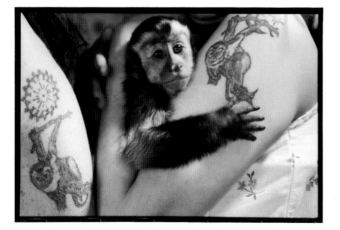

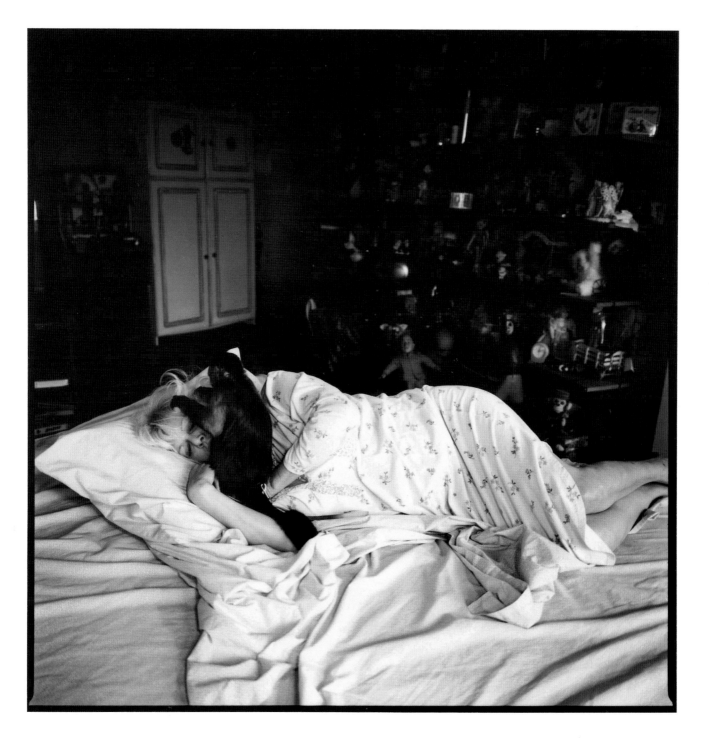

34

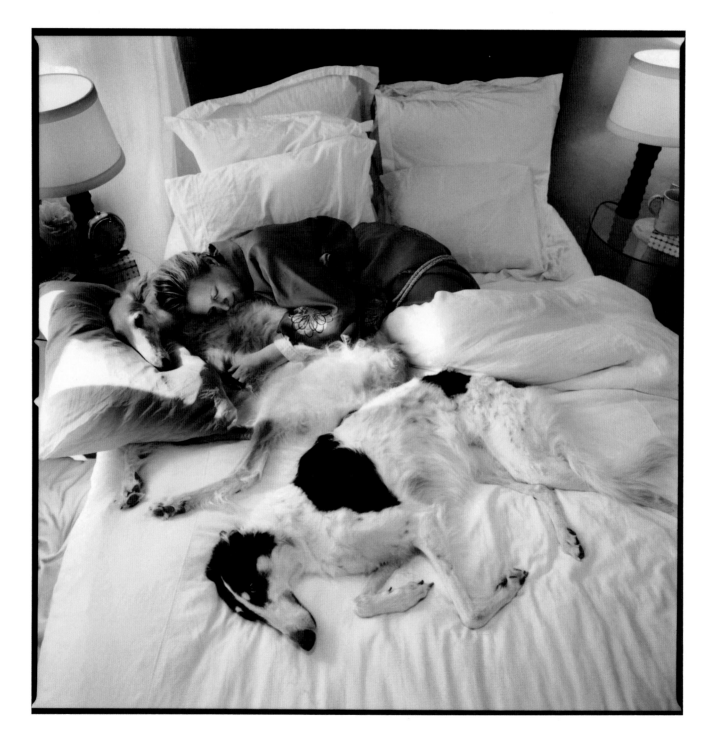

NOODLE & BEE *with* JANE FARRAR

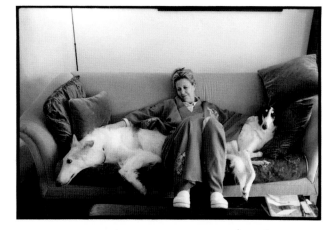

Perhaps that is the appeal of sleeping with a dog—that it is a mere fur's-breadth away from the sensual ecstasy of sleeping with one's children, or the comfort and reassurance of sleeping with one's spouse, without any of the complications attendant on either of those relationships. Dogs always think you are good in bed. Dogs do not have nightmares or lose their pacifier in the middle of the night, or hear the wind worrying the windows and think it's Charles Manson, out on parole. . . . They do not suddenly remember that tomorrow is the school Thanksgiving play and they must have a potato costume by 8:30 in the morning. . . . They are always the right temperature, regardless of the status of the covers. Dogs don't feel amorous while you're busy reading Dostoyevsky. . . . They do not mind if you kick them when you turn over, or if you snore louder than they do. They do not fantasize about being in bed with someone else—someone half your age, for instance. In short, it's a wonder anyone can stand to sleep with people.

—DANA STANDISH, from "Sleeping With Dogs," *The Bark Magazine*

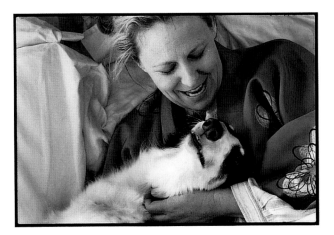

FAUST & SPARTACUS
with SAGE BEAMAN

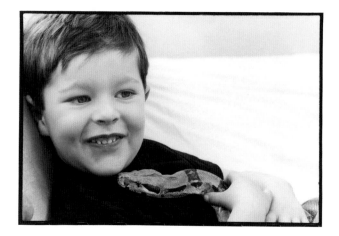

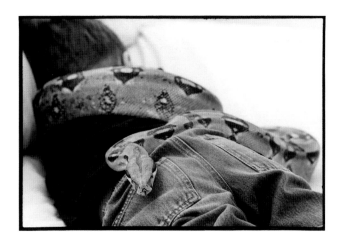

"Everybody is all right really."

—Edward Bear *in Winnie-the-Pooh by* A. A. MILNE

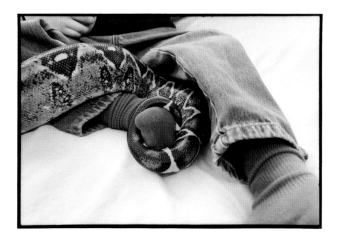

EMMA & ATLAS *with*
MARK TAMOGLIA & JAY GONDEK

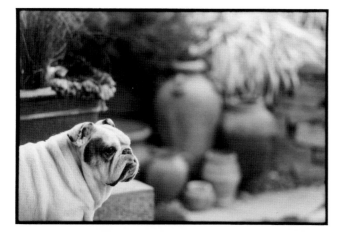

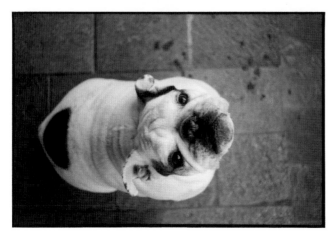

Every dog should have a man of his own . . . The first problem a dog faces is to pick out the right man—a gay and affectionate disposition is more important than an expensive pedigree . . . Also, since a dog is judged by the man he leads, it is a good idea to walk the man up and down a couple of times to make sure his action is free and he has springy hindquarters. . . . Training a man takes time. Some men are a little slow to respond, but a dog who makes allowances and tries to put himself in the man's place will be rewarded with a loyal pal.

—COREY FORD, *The Literary Dog: Every Dog Should Have A Man*

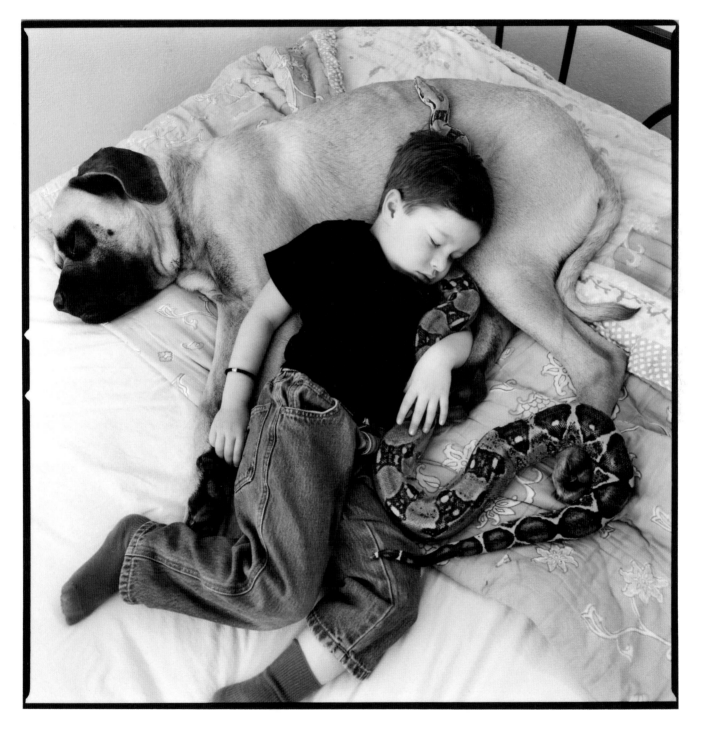

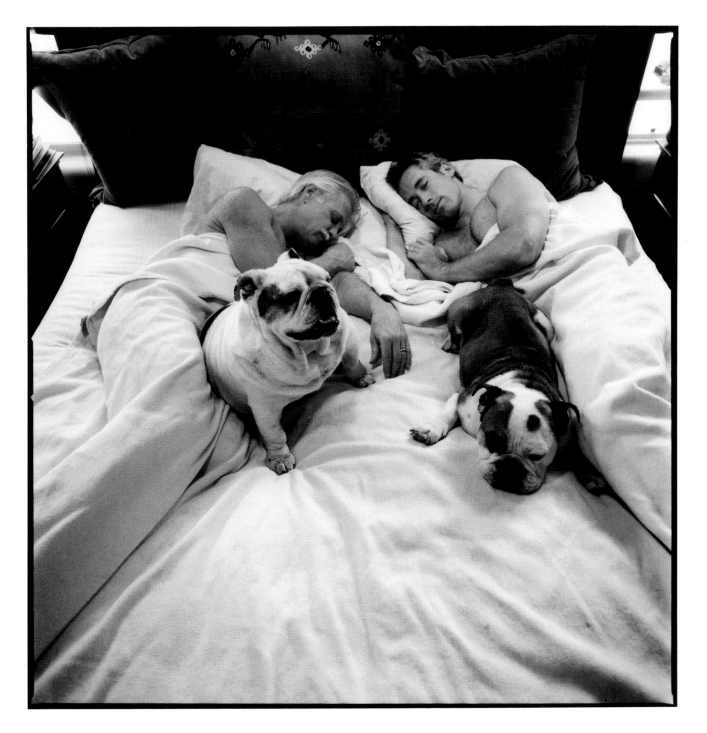

BANDIT *with* JOSH GROSECLOSE &
CHEXMIX *with* JANNA GROSECLOSE

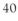

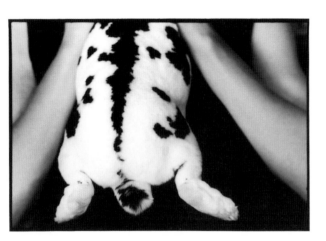

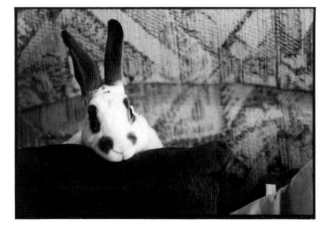

People remember the relationship with their first pet as taking place in a simpler time in their lives, even though most of what you go through growing up is far from simple. As kids, we try to find a pattern in all of the stimuli, decide what to trust and what to fear, and along the way experience our first joy, connection, rejection, loneliness, and heartbreak. We face some of our largest challenges and most memorable triumphs. Frequently, the companionship of pets is the constant that gets us through.

—DR. MARTY BECKER, *The Healing Power of Pets*

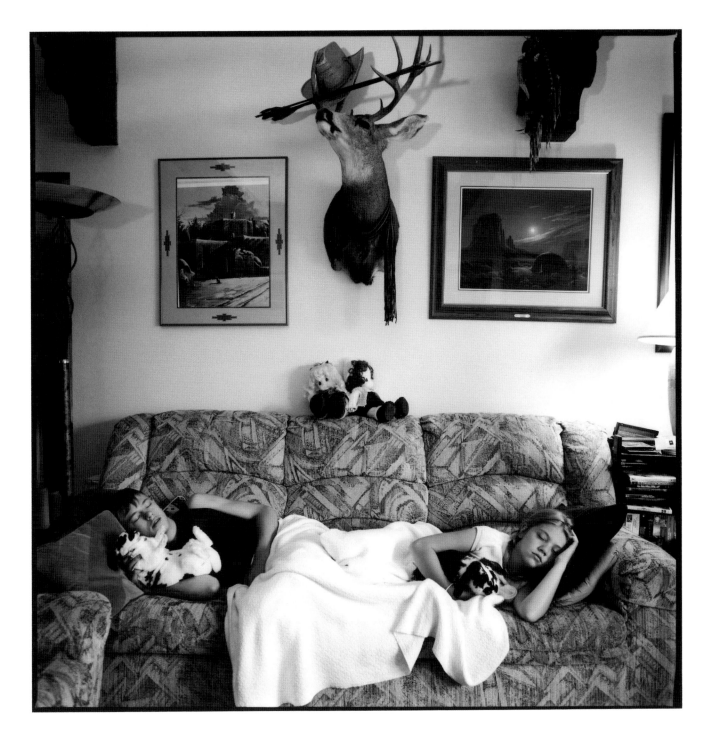

KIRBY & RUDY *with*
RHONDA & MATT KING

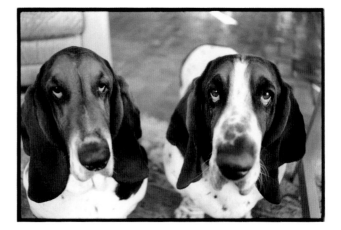

42

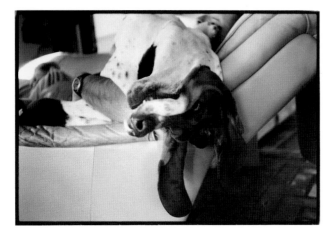

Observing a dog is an exercise in appreciating the gifts of the nonhuman. Dog people try to put more "nature" in the concept of human nature. Dog people feel that seeing their dog basking on a sunny pane of carpet is a good reason to snuggle up for a snooze; they take the thumping tail as reassurance that yielding to the moment was the right decision.

—MICHAEL J. ROSEN, *Dog People*

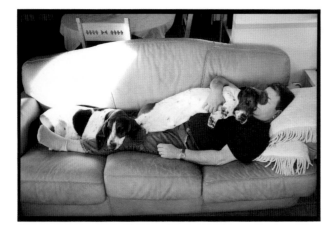

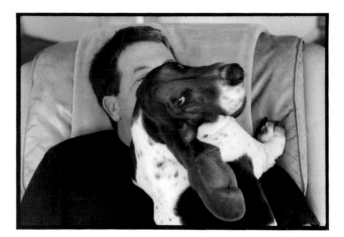

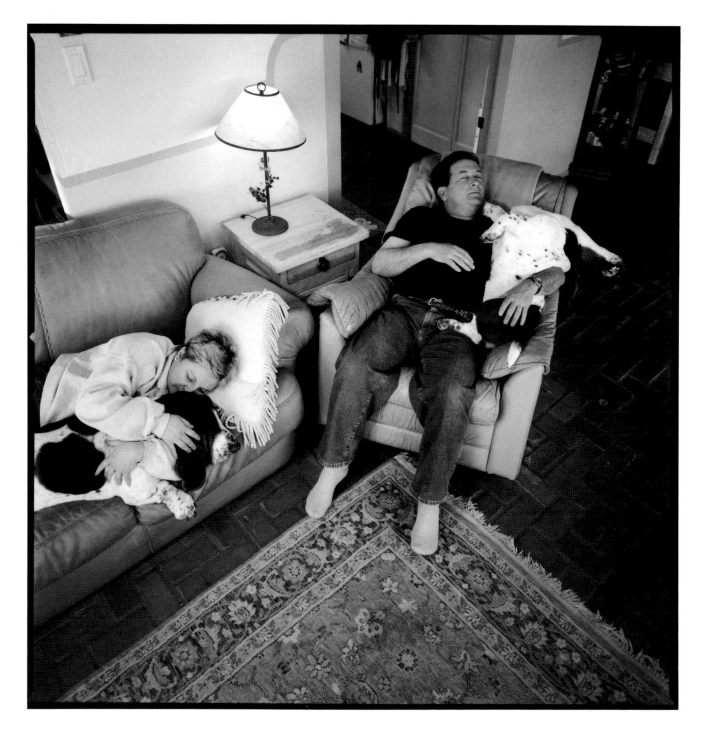

44

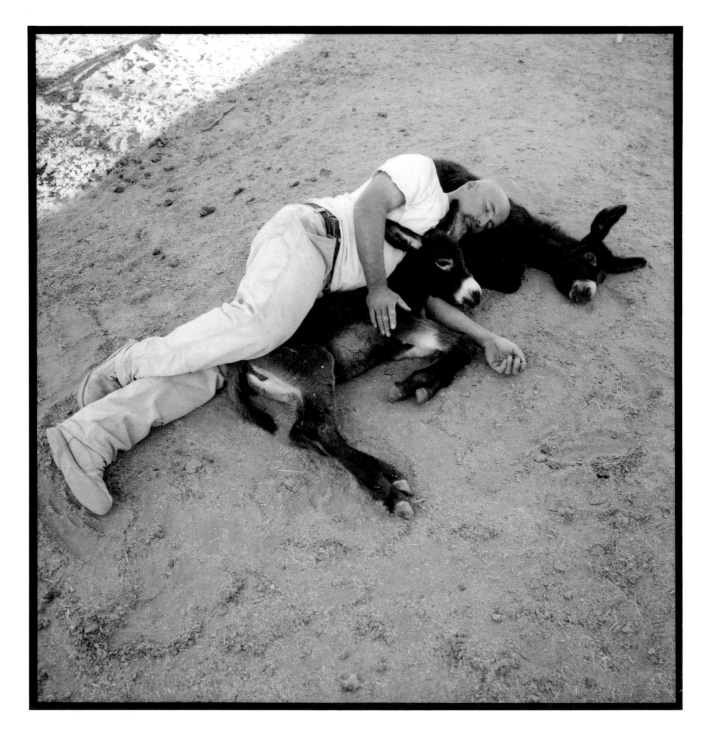

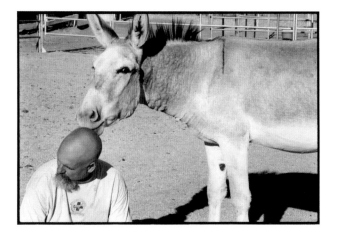

BABY GIRL & LITTLE GIRL
with MARK MEYERS

Not to hurt our humble brethren is our first duty to them, but to stop there is not enough. We have a higher mission— to be of service to them wherever they require it.

—SAINT FRANCIS OF ASSISI

45

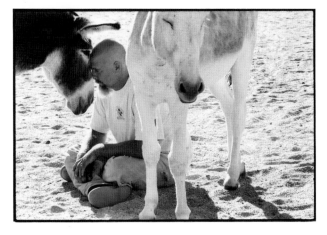

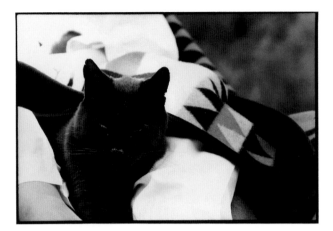

MARLOWE *with* PEGGY PFEIFFER

There are no search-and-rescue cats, guard cats, Seeing Eye cats, bomb-detecting cats, drug-sniffing cats, escaped-convict-tracking cats, sheep cats, sled cats, gun cats, obedience-trained cats, Frisbee-catching cats, or slipper-fetching cats. This is a matter of considerable relief. . . . No one has any illusions about cats. Cats are cats, and any real cat owner knows it.

—STEPHEN BUDIANSKY, *The Character of Cats*

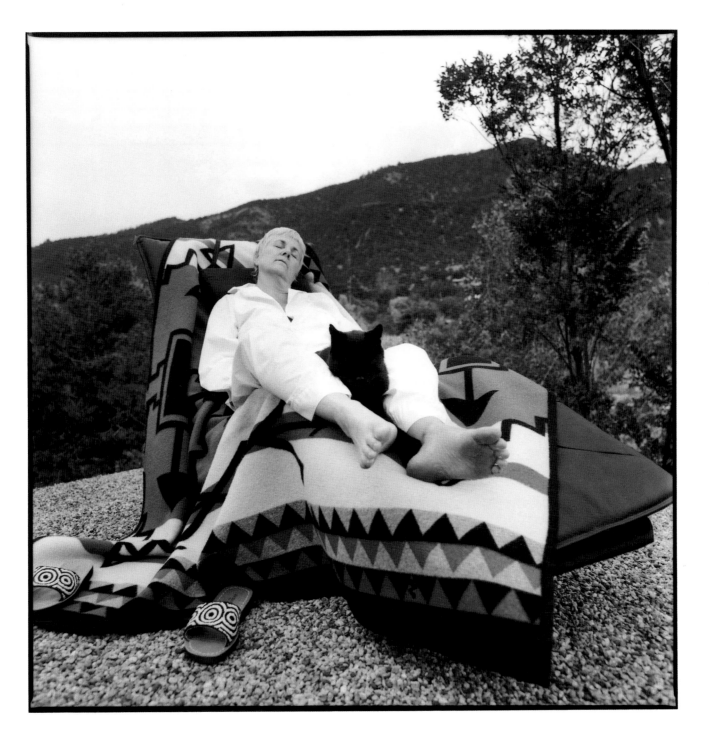

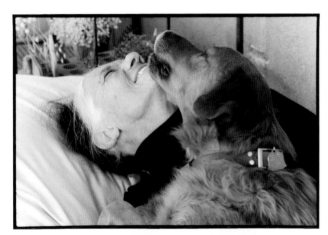

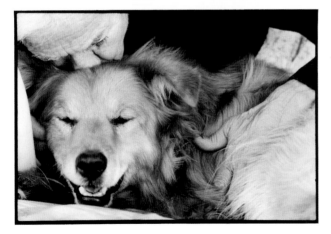

HUEY, MARY WILLIAM & SANDY SWEETPEA *with* THEO RAVEN

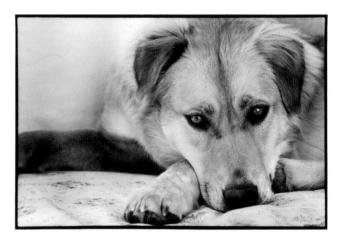

. . . animals have always awakened something in me—their little joys and travails alike—that, try as I might, I find impossible to express except in the language of devotion. Maybe it is the Lord's way of getting through to the particularly slow and obstinate, but if you care about animals you must figure out why you care. From a certain angle it defies all logic, often involving, as in the case of pets or the strays who find our doors, all sorts of inconveniences and extra worries one could do without. And the only good reason I know to care for them is that they are my fellow creatures, sharing with you and me the breath of life, each in their own way bearing His unmistakable mark.

—MATTHEW SCULLY, *Dominion: The Power of Man, the Suffering of Animals, and the Call to Mercy*

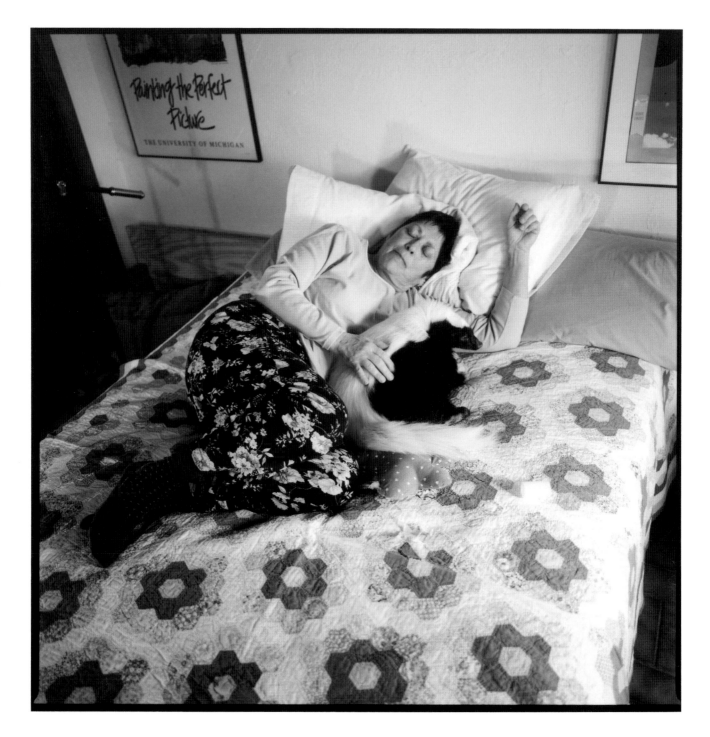

BUTTON *with* GLORIA SHARP

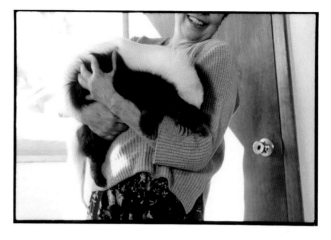

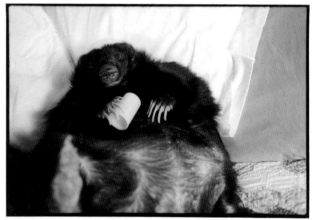

Animals hold us to what is present: to who we are at the time, not who we've been or how our back accounts describe us. What is obvious to an animal is not the embellishment that fattens our emotional resumes but what's bedrock and current in us: aggression, fear, insecurity, happiness, or equanimity. Because they have the ability to read our involuntary tics and scents, we're transparent to them and thus exposed—we're finally ourselves.

—GRETA EHRLICH, *The Solace of Open Spaces*

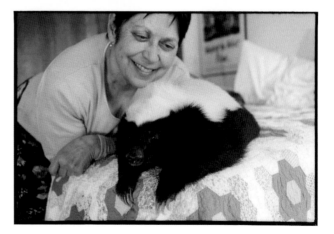

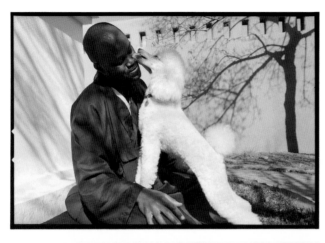

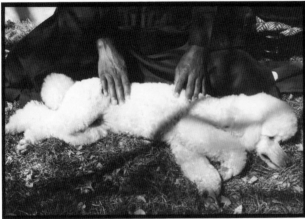

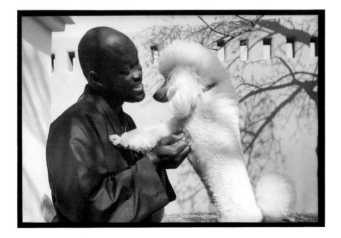

BELLA *with* DEWITT BOLDEN

Without animals to share the motions of our lives we are diminished, our lives are less than whole. This impoverishment is one of our saddest and loneliest bargains with civilization. . . . chanted stories and sacred dance ceremonials, which link all creatures endowed with eyes and breath and heartbeat, bespeak a time when the world was not divided into animal and human, divine and non-divine. . . . A time when we understood the animals when they spoke to us and taught us how to survive and how to worship . . . Our common needs and determined deaths link us. Our common life source declares our union. We are promised to each other and to believe this covenant is to love our animal wits and blessed instincts and sensual bodies.

—MEINRAD CRAIGHEAD, *Meinrad Craighead: Crow Mother and the Dog God, A Retrospective*

Java *with* Dean Harrison &
H.G. Saginaw *with* Prayeri Harrison

54

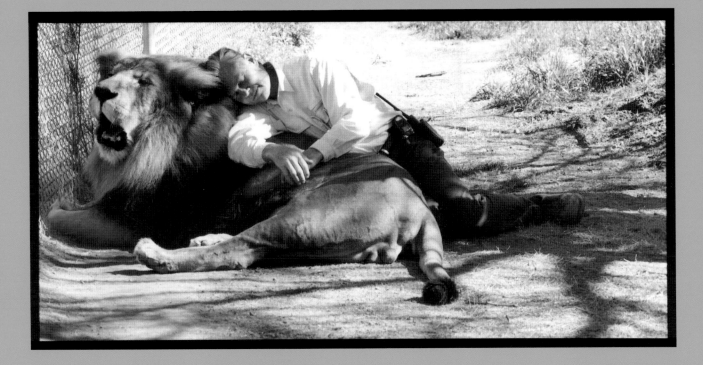

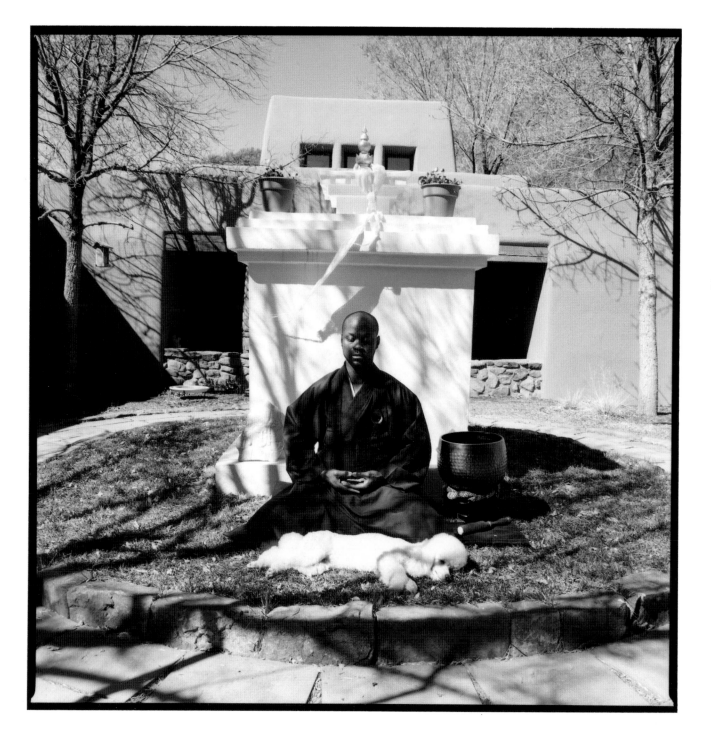

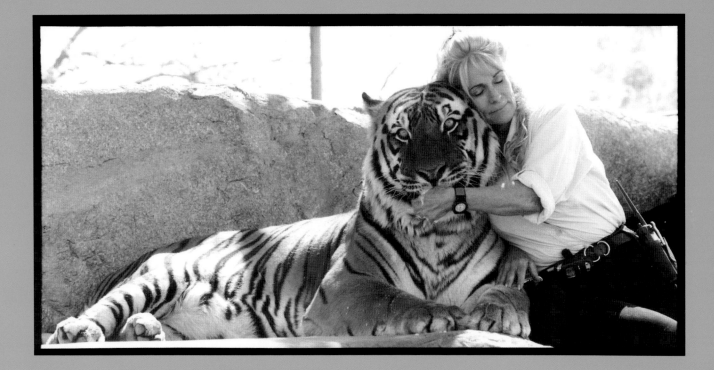

Instincts are non-thinking, non-restrictive, unlearned motivators of behavior, which cannot be removed or trained out of an animal. Therefore, big cats can never be considered tame, domesticated pets. They are "wild by nature." The wildness is inherent in the creature itself. Many people feel they can keep a big cat like a house cat, dog or horse. This is a major error and can produce a false sense of security.

—DEAN HARRISON, *Return to Eden*

ROXIE, MARTHA, BUSTER & RUDOLF *with* CARTER HOWELL

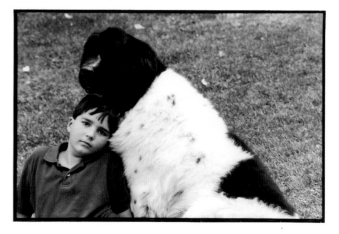

Out beyond ideas of wrongdoing and rightdoing,
there is a field. I'll meet you there.

When the soul lies down in that grass,
the world is too full to talk about.
Ideas, language, even the phrase each other
doesn't make any sense.

—JELALUDDIN RUMI, *The Essential Rumi,*
 translated by Coleman Barks

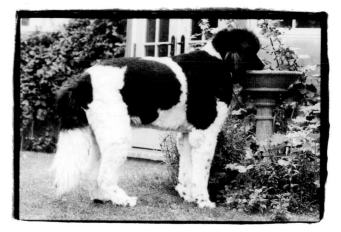

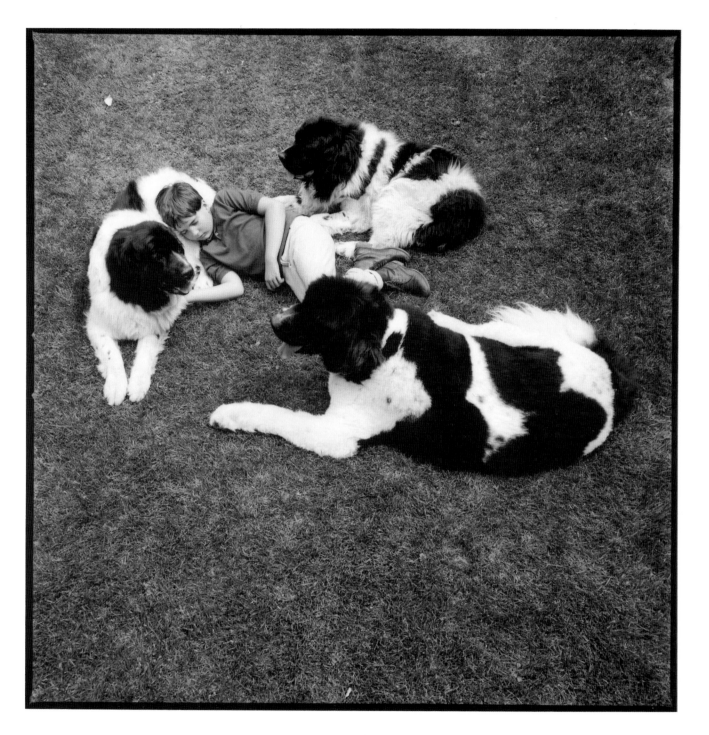

SIVA *with* NANETTE LASHAY

Our culture invariably supposes that action and accomplishment are better than rest, that doing something—anything— is better than doing nothing. Because of our desire to succeed, to meet these ever-growing expectations, we do not rest. Because we do not rest, we lose our way. We miss the compass points that would show us where to go, we bypass the nourishment that would give us succor. We miss the quiet that would give us wisdom. We miss the joy and love born of effortless delight.

—WAYNE MULLER, *Sabbath: Finding Rest, Renewal, and Delight in Our Busy Lives*

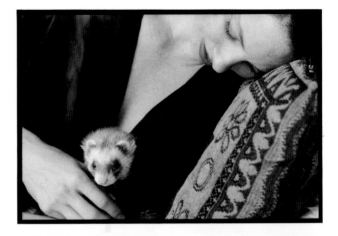

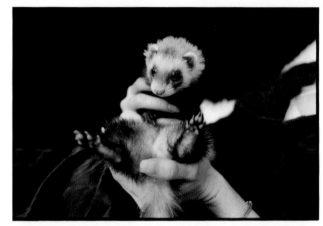

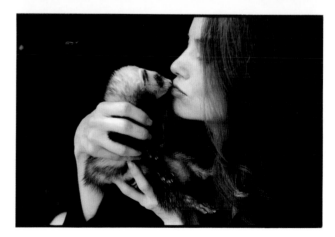

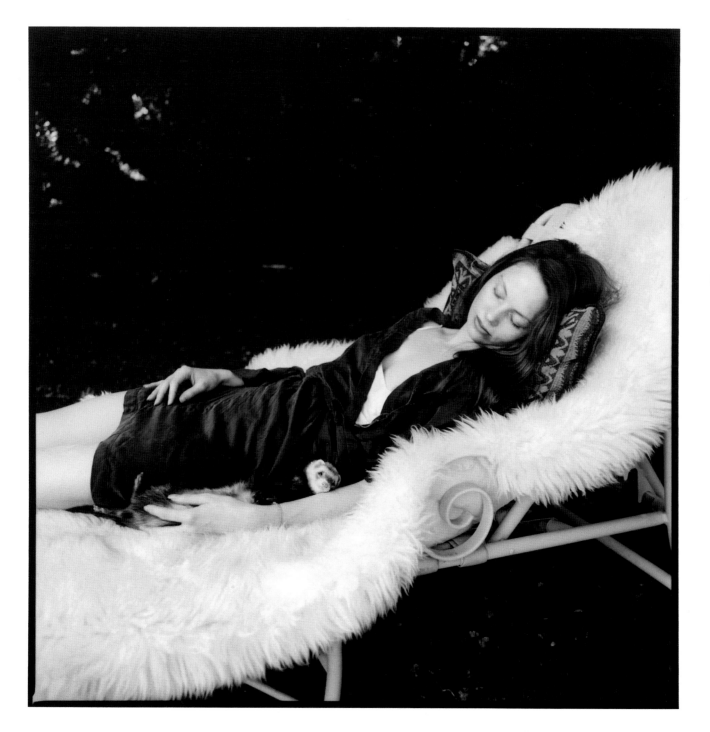

COORS, LEROY & TINA *(kitties),*
JUBAL, COCO, MING, & RED *(doggies)*
with DAWN & PAUL BICK.

POOKIE, *the fourth kitty, would settle only
for a personal photo (below).*

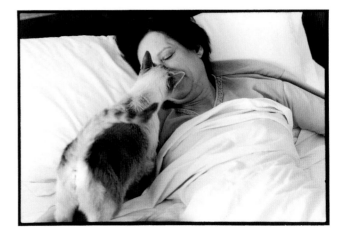

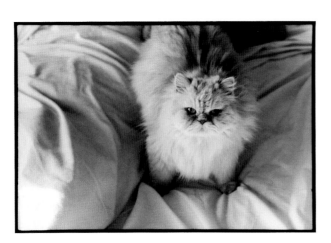

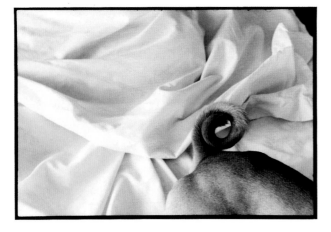

These sleepers provide a strange and interesting subject— these are beloved dreamers, in our power, but gone from us; alive, but unawake. They are unconscious witnesses; they are dreaming, trusting, vulnerable, reminding us of the other world we live in, underneath our waking world.

—ROXANA ROBINSON, from a review in *The Bark Magazine*

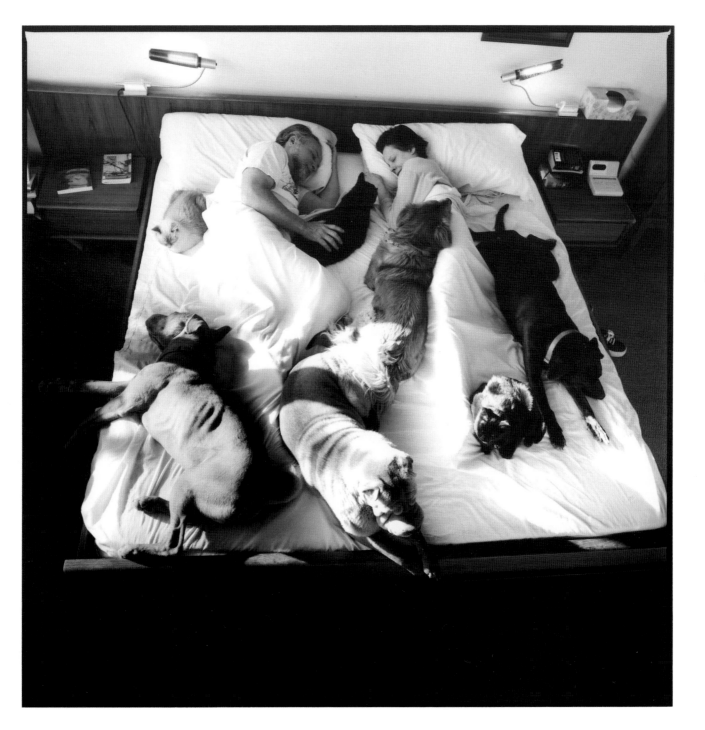

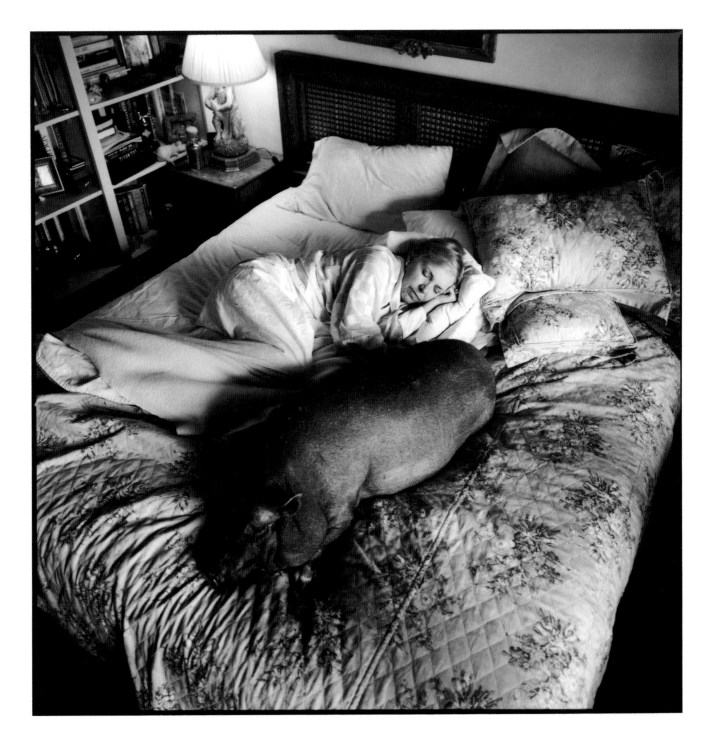

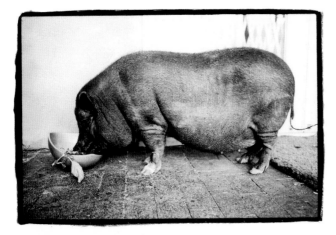

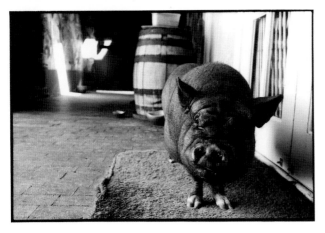

SOME PIG
—as spun in *Charlotte's Web* by E.B. WHITE

64

DESTINY & BOGART
with LORENZO WALLACE
& RAMONA HEISE

Lying at our feet, curled up at the foot of our beds, or munching in our pastures, are beings who can teach us everything we are seeking. We have only to learn how to listen.

—KATE SOLISTI-MATTELON, *Conversations With Dog:*
An Uncommon Dogalog of Canine Wisdom

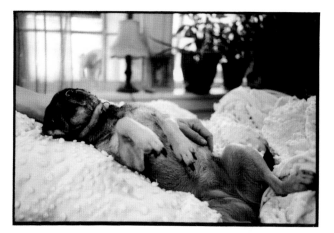

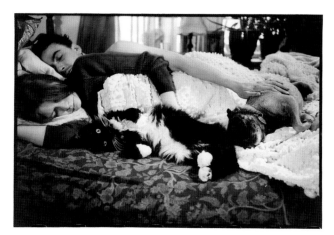

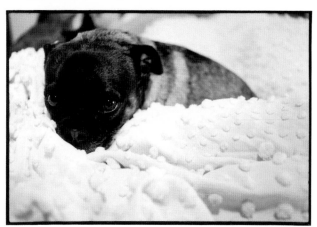

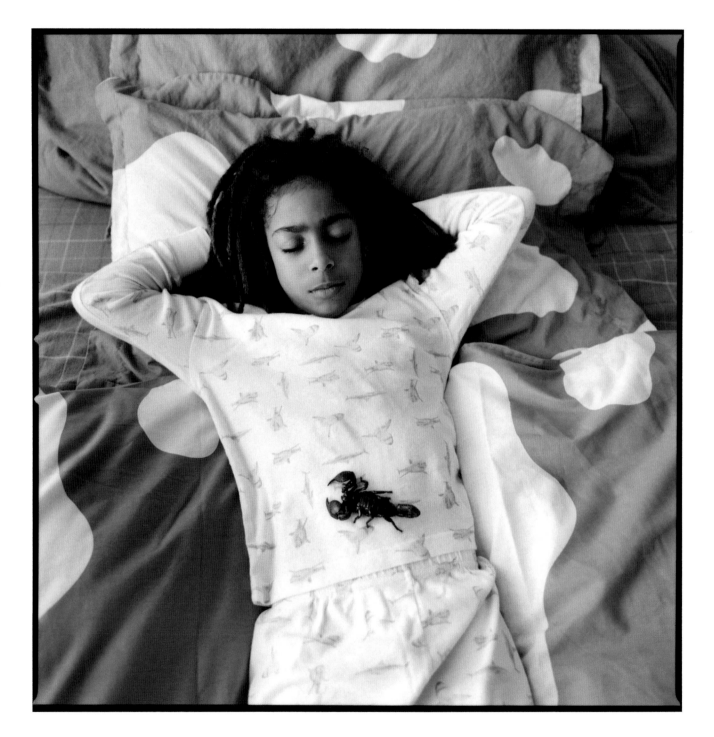

SCORPIO *with* LUCAS HARARI

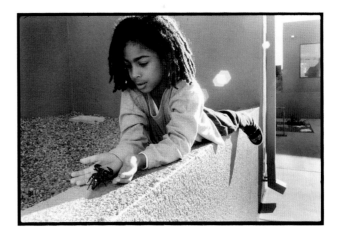

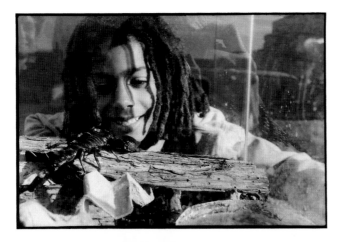

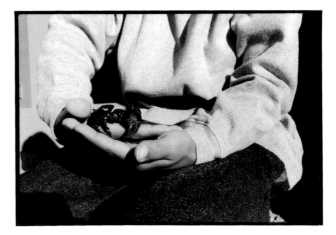

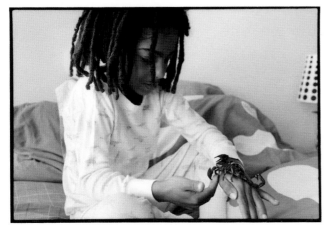

Possibly the greatest gift we can give our children is to instill in them a sense of awe and wonder and respect for all living creatures. For if we can show concern for the smallest moth, then surely they will respect one another more.

—JANE GOODALL

FREDERIC, TALLIE & BENSON
with JIM LACHEY

68

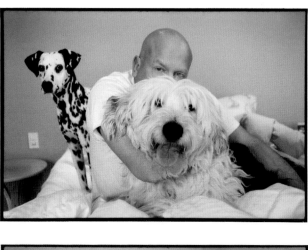

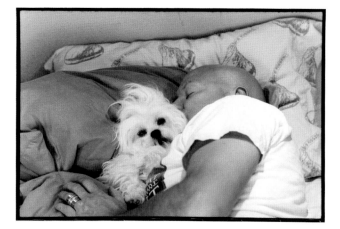

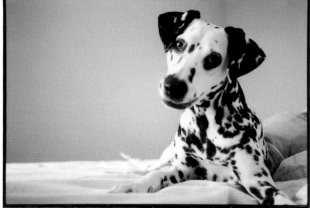

The eyes of a dog, the expression of a dog, the warmly wagging tail of a dog and the gloriously cold damp nose of a dog were in my opinion all God-given for one purpose only—to make complete fools of us human beings.

—BARBARA WOODHOUSE, *No Bad Dogs*

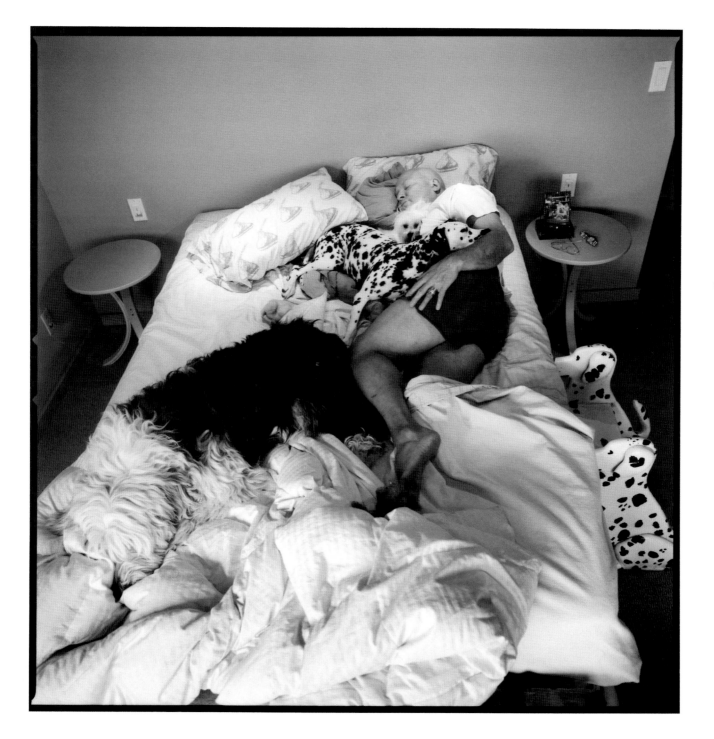

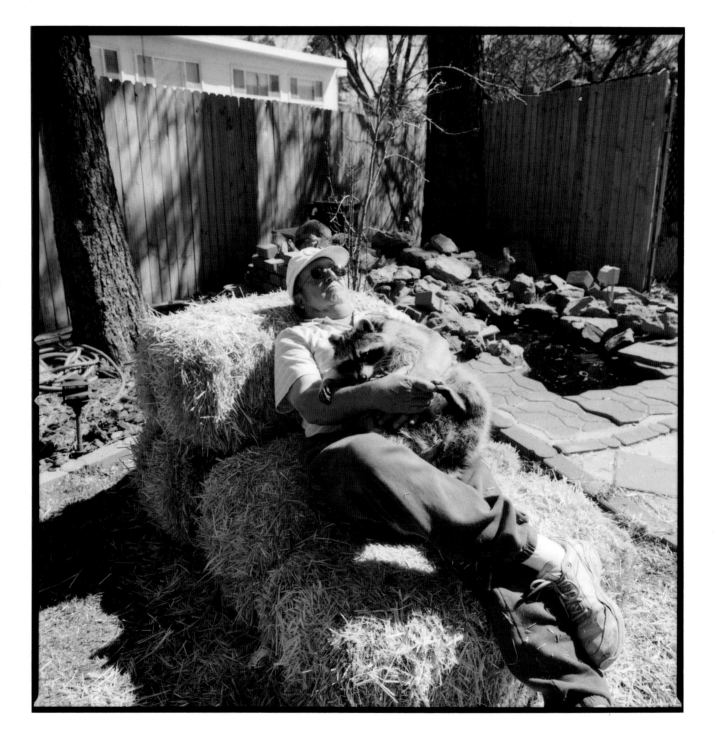

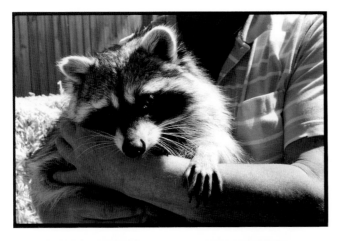

GROVER *with* BOB ANDERSON

It was quite incomprehensible to me . . . why in my evening prayers I should pray for human beings only. So when my mother had prayed with me and had kissed me goodnight, I used to add silently a prayer that I had composed myself for all living creatures. It ran thus: "O Heavenly Father, protect and bless all things that have breath; guard them from all evil, and let them sleep in peace."

—ALBERT SCHWEITZER

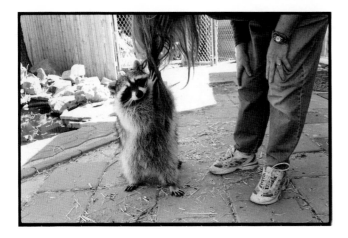

EMILY *with* MARY LOU COOK

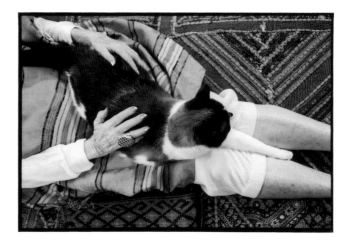

72

Never again will I settle for the phrase "only an animal" to describe one of my fellow creatures. The animals, themselves, through their loyalty, bravery, commitment, and love, have stated, more eloquently than any words might say, that we are all sentient and conscious beings, each holding within us that spark of the divine.

—STEPHANIE LALAND

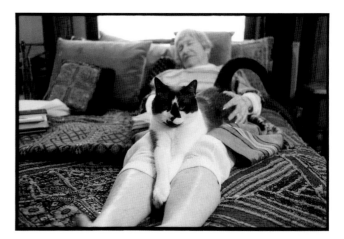

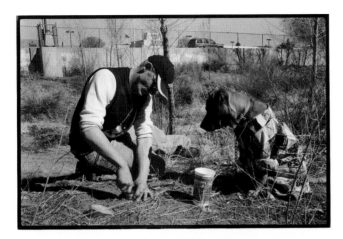

74

It is not true that a dog is a dog is a dog. They are all individuals. Their ability to spring back after unbelievable mishandling, their sense of humor, their ability to bring us back to everyday life—it is all amazing. Regardless of what goes on in our lives, who we are, dogs are great levelers. They are simply not impressed. They want us for who we are, not what we are.

—ROGER A. CARAS *The Bond: People and Their Animals,* from an interview with Brain Kilcommons

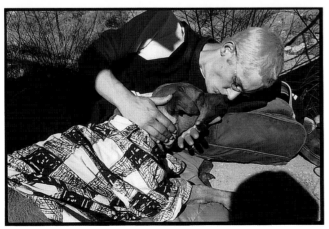

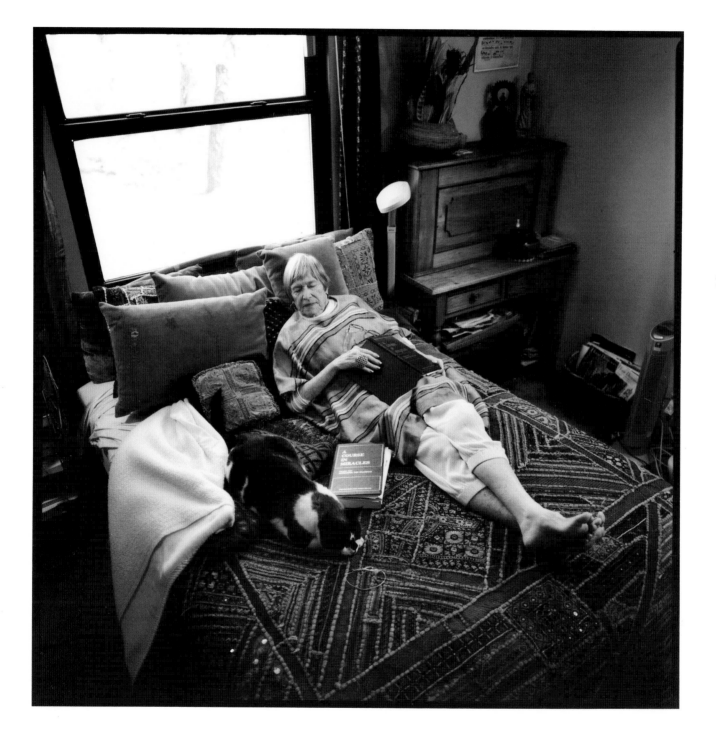

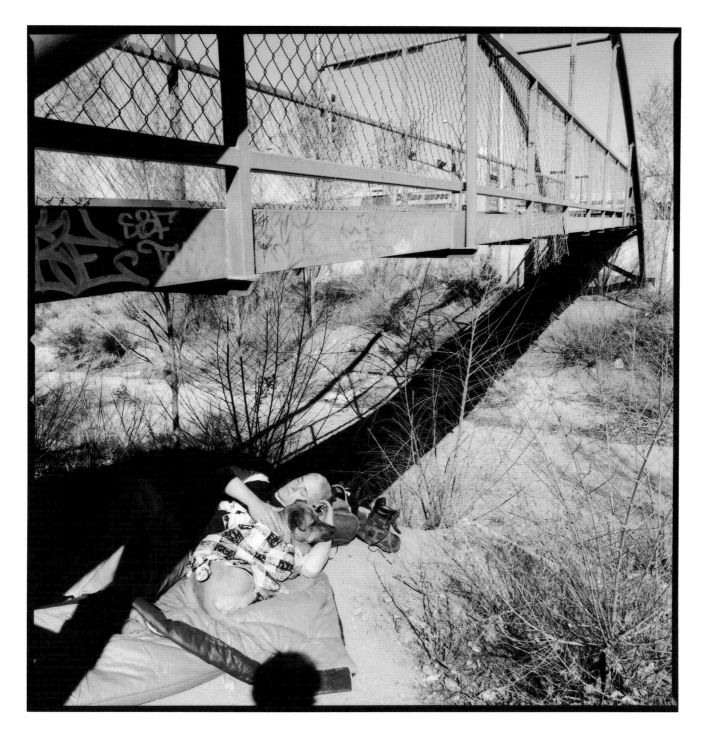

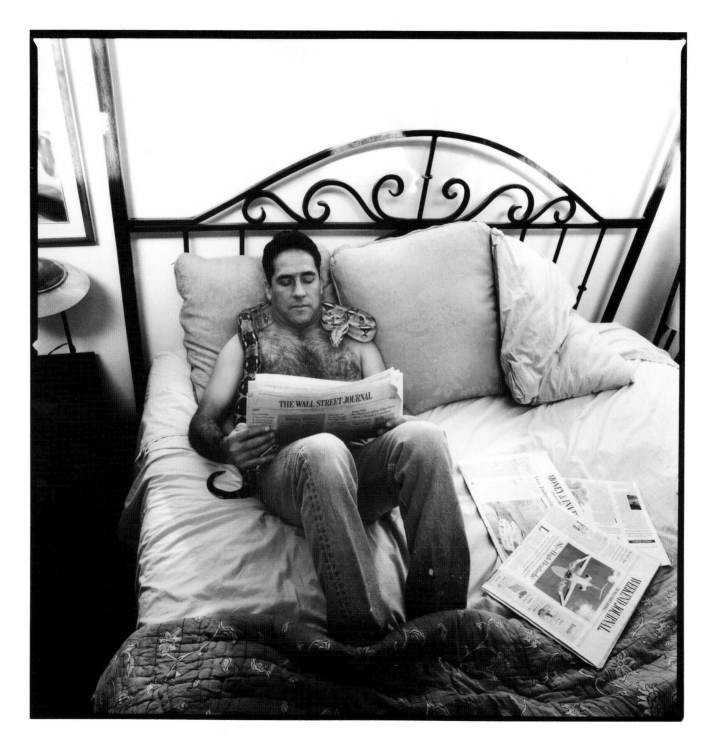

FAUST *with* RICK BEAMAN

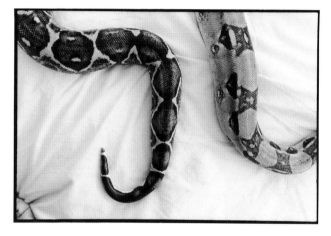

Of all the reptiles—and maybe even all the animals—the snake has been the subject of great controversy and paradox. . . . Before the snake begins to shed its skin, its eyes will begin to cloud over. It gives the snake a trance-like appearance. To many mystics and shamans this indicated the ability of the snake to move between the realms of the living and the dead, of crossing over from life to death and then back to life again. As the skin begins to shed, the eyes begin to clear as if they will see the world anew. For this reason, alchemists often believed that wisdom and new knowledge would lead to death and rebirth, enabling the individual to see the world from an entirely new perspective.

—TED ANDREWS, *Animal-Speak*

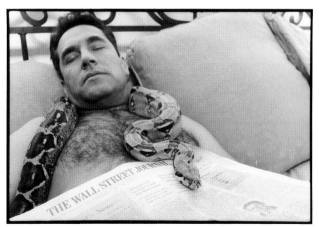

EDISON *with* ARIEL FREILICH

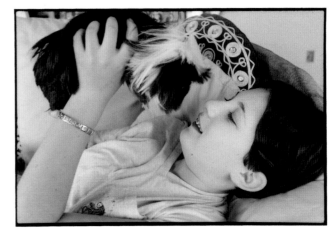

78

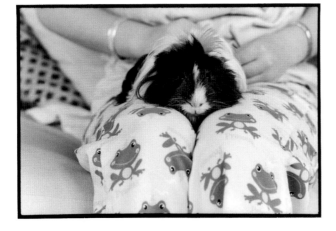

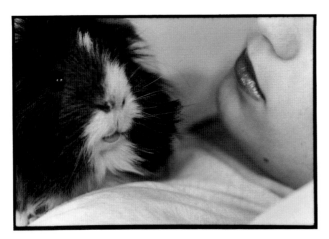

. . . if one of your greatest joys is animals, trust that joy. . . . Watch a cat in the sun. Spend time feeding ducks at a lake. Take a dog for a brisk walk and let him stop to sniff each piece of mysterious, delectable sidewalk gunk. Watch a hummingbird on a spring flower. Sit quietly by a stream and watch for streaks of silver on a fish's back. Listen in the dark on a moonless night for the conversations of owls and frogs. Breathe in all the joy that greets you in any given moment. It is a blessing and a healing.

—SUSAN CHERNAK McELROY, *Animals as Guides for the Soul*

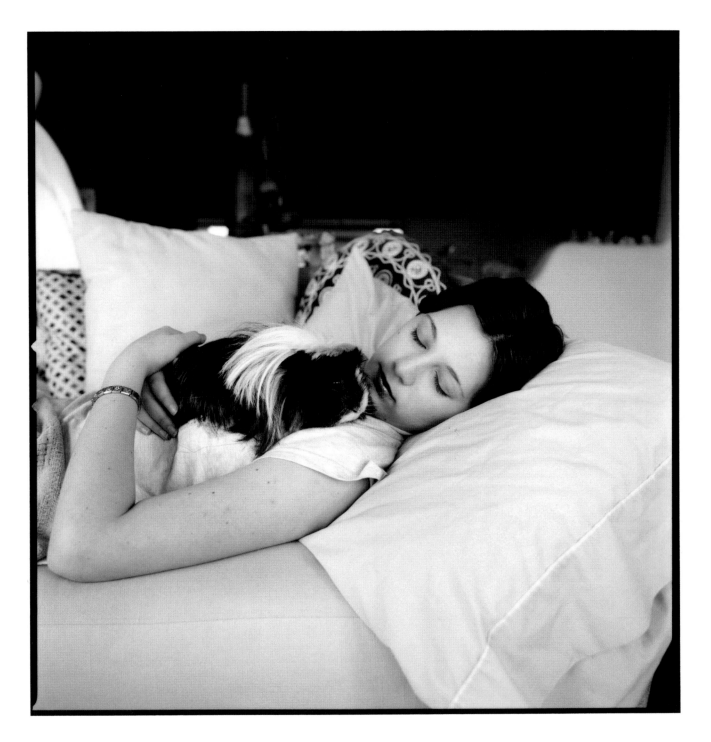

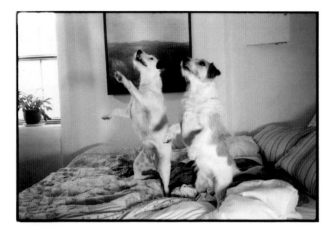

ARCHIE & BISCUIT
with REBECCA FITZGERALD

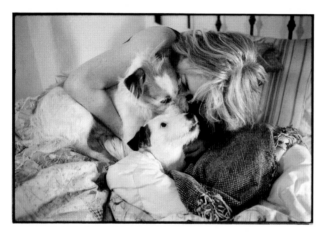

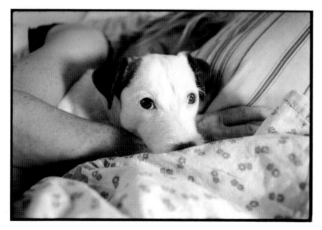

I am sleeping with a dog. It's two a.m., maybe three, and I wake up to find her small, slender face a foot or two away from mine, eyes fixed on me. This is the dog's silent vigil, and like most of her behaviors, it has great purpose. If the vigil fails, if the dog stares at me and I don't stir, she will employ an alternative strategy, licking my hands and face until I comply. This is dog code; it means: Wake up and let me under the covers, please, and like so many aspects of life with a dog, it has become a ritualized event that seems to please us both deeply. I wake up, say, "Okay," then pull the covers back. She creeps in headfirst and curls against my stomach, her nose pressed against my knees. And we both sigh. I feel so profoundly contented at those moments, snuggled under the covers with the dog, that I sometimes resist the pull back toward sleep, and I lie there for a few minutes, trying to soak up the feeling: intimacy.

—CAROLINE KNAPP, *Pack of Two: The Intricate Bond Between People and Dogs*

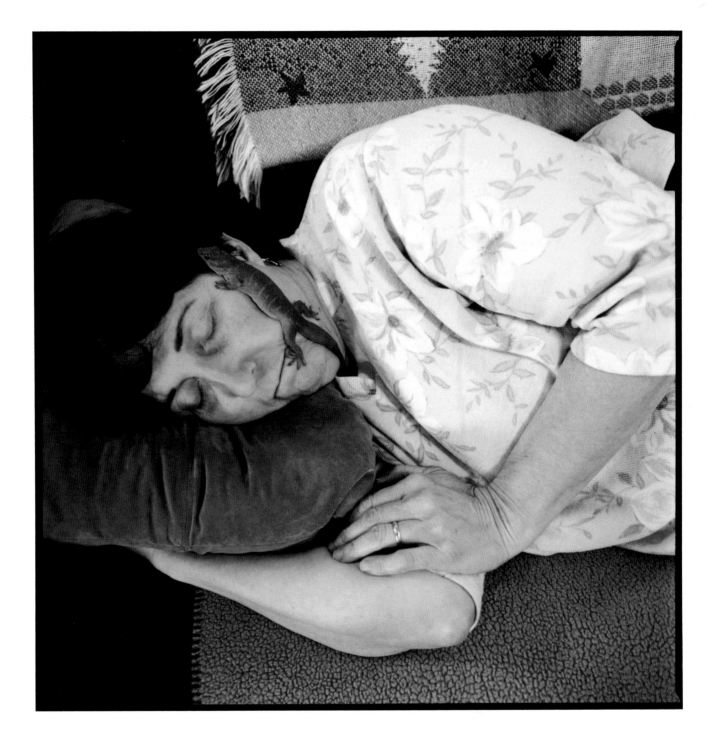

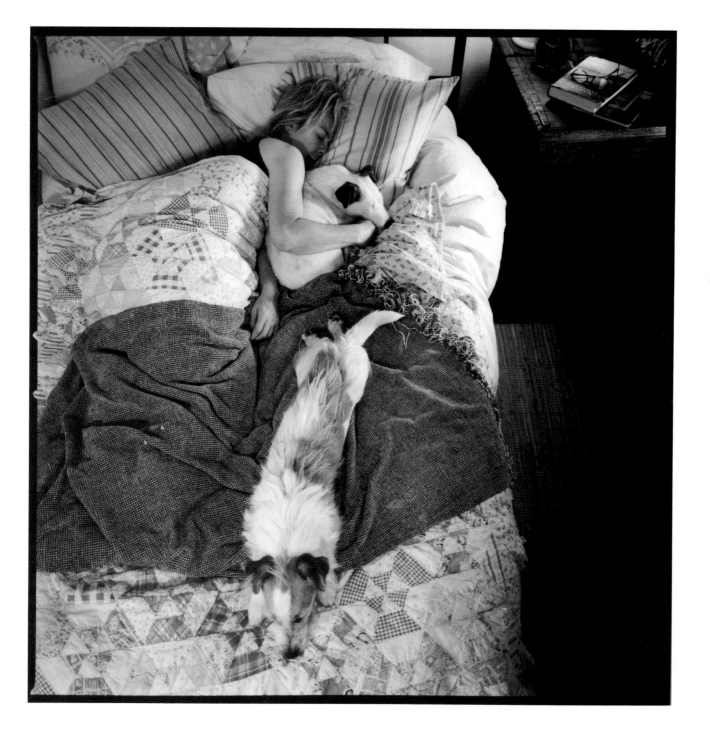

GOJI & SHARLA *with* NANCY STOKES

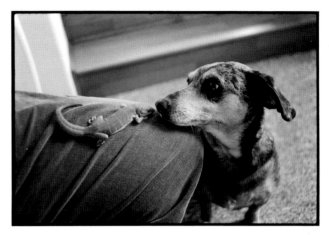

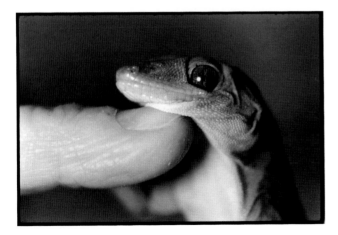

We recognize that animals seem to feel more intensely and purely than we do. Perhaps we yearn to express ourselves with such abandon and integrity. Animals fully reveal to us what we already glimpse: it is feeling—and the organization of feeling—that forms the core of self. We also sense that through our relationship to animals we can recover that which is true within us and, through the discovery of that truth, find our spiritual direction. Quite simply, animals teach us about love: how to love, how to enjoy being loved, how loving itself is an activity that generates more love, radiating out and encompassing an ever larger circle of others.

—MARY LOU RANDOUR, *Animal Grace*

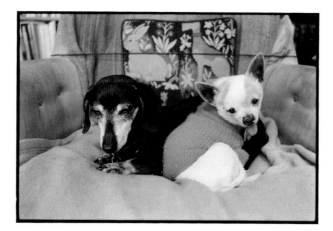

TICO, HEIDI, SNOWFEATHER,
SAMMY, WILLIE & SOPHIE
with ULLA PEDERSEN

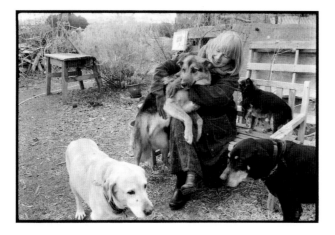

There's a world behind the world we see that is the same world but more open, more transparent, without blocks. Like inside a big mind, the animals and humans all can talk, and those who pass through here get power to heal and help.

—GARY SNYDER

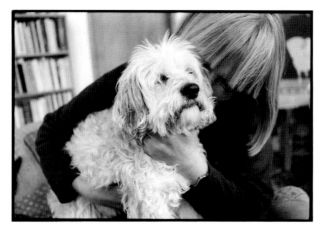

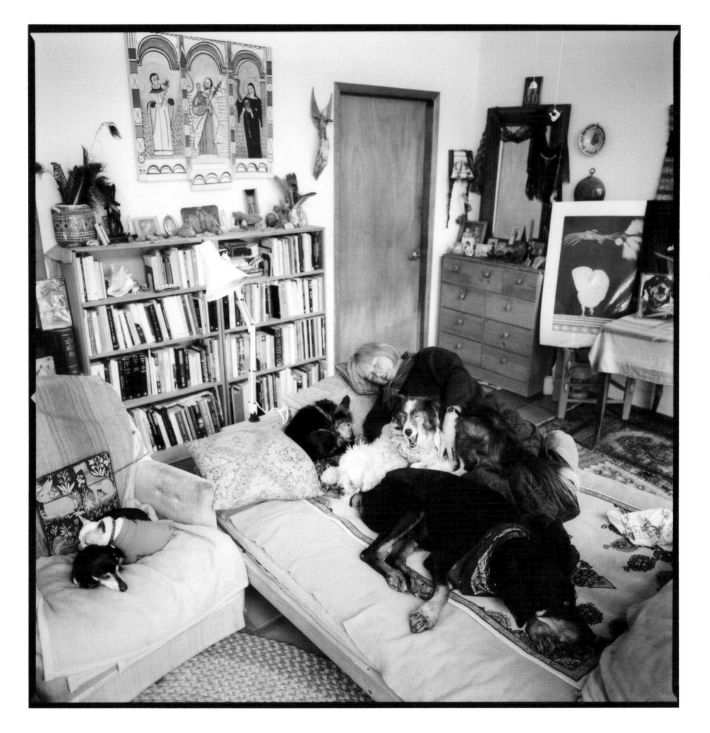

Scott *with* Sarah Williams

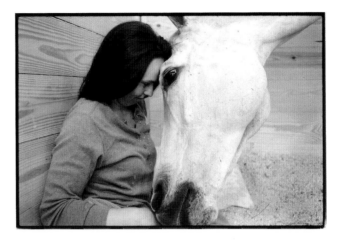

86

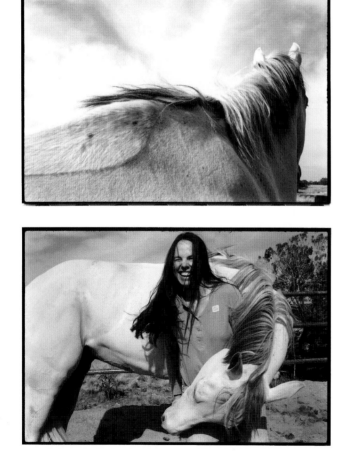

A woman's relationship with a horse is an encounter between the intangible—the spiritual, the mythical, the ethereal—and the very tangible: the physical everyday realities of riding, horse-keeping, and life itself. In my life and in the lives of many women, the two extremes meet and merge seamlessly, contrasting and explaining each other in a way that makes both realities more clear. The concrete act of being outside on my horse, the gritty actuality of dust and dirt and wind and sun, somehow stirs the less shaped and more inexplicable interior within me. The tactile experience of brushing my mare gives me a sense of larger connectedness with my universe.

—Mary D. Midkiff, *She Flies Without Wings:*
How Horses Touch A Woman's Soul

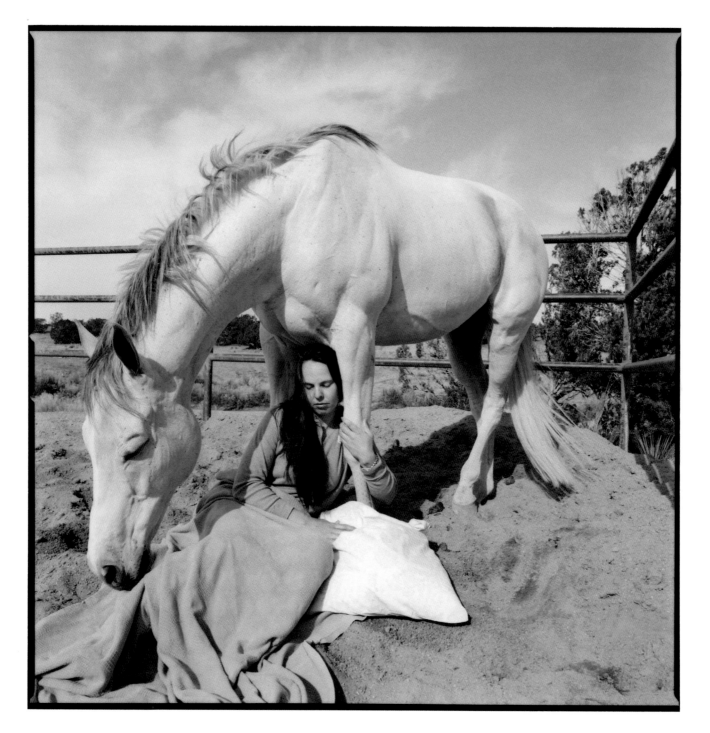

44

SABRINA & RAY RAY
with BETTY KYLE

Canines correct the existential imbalances of human beings, such as our insatiable need for affection and the constant gratification of our primary sense—which is touch. Dogs never walk away from petting, scratching, or stroking. And even when you are momentarily sated, a dog will put his head in your lap and look up (eyes wet with adoration) for more. No matter how loving your mate, no matter how huggy-kissy your kid, doglessness spells tactile deprivation. Dogs are not subtle. They shiver and drool at your touch. They have no secrets and no false pride as they wait for you to get down on the floor and play, like a mammal, at last.

—ANITA DIAMANT, *Pitching My Tent*

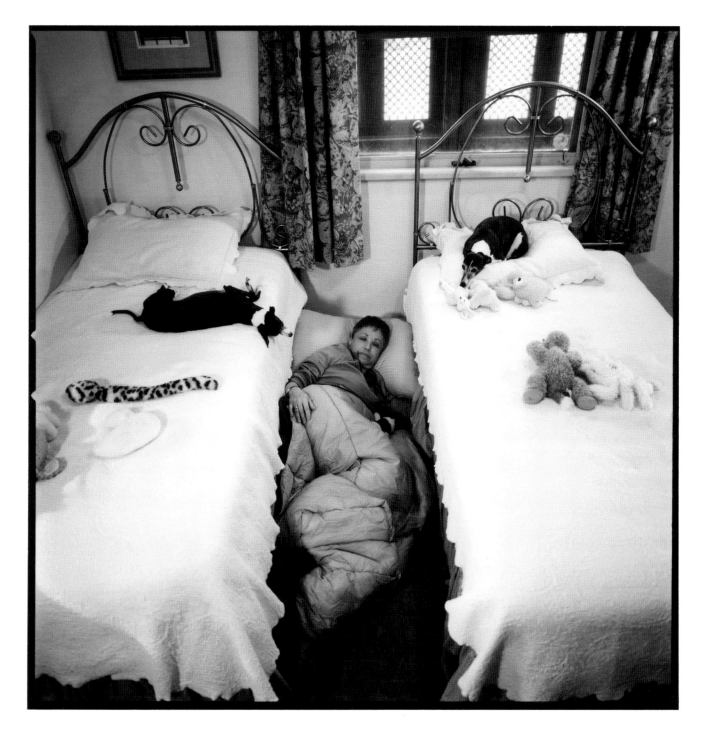

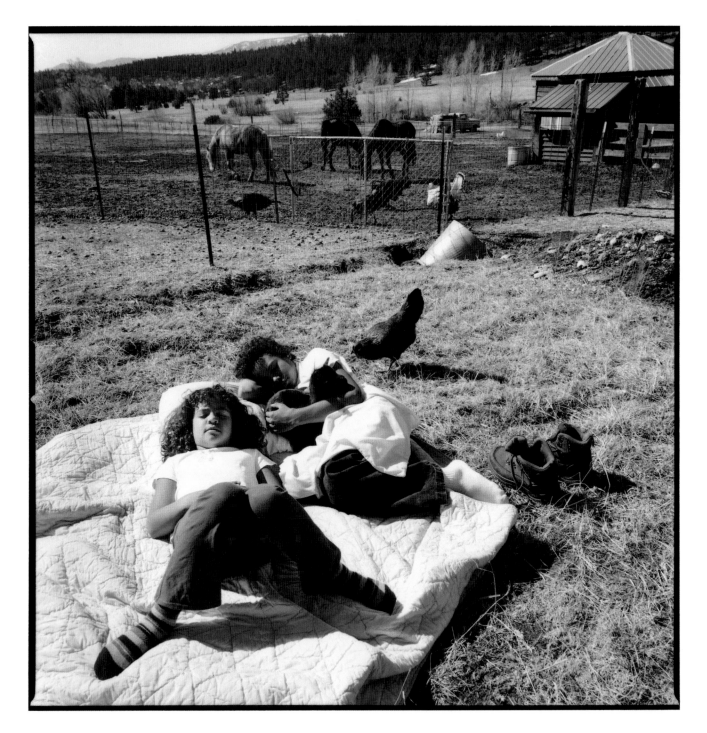

BLACK SNOW *with*
ELIZA & RAFAEL MCLEOD

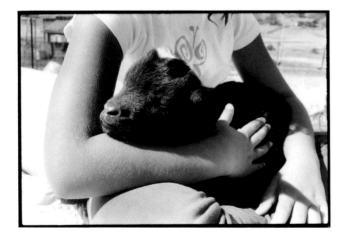

Direct encounter with animals, meeting them eye-to-eye on their own ground, evokes a sudden wonder and respect. Their vivid life brings us alive to the source that creates and sustains all beings. Without such encounters we risk losing that part of ourselves which most deeply resonates with nature—the heart of compassion.

—"Benediction for the Animals" in *Earth Prayers: From Around the World,* edited by ELIZABETH ROBERTS & ELIAS AMIDON

MOLLY *with*
ASHISHA & CAROLYN LAKE

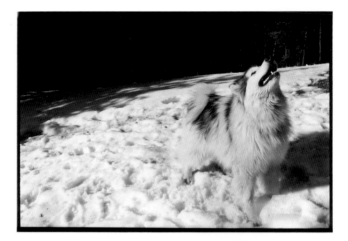

. . . Those of you who have an animal and live in close proximity to nature will understand immediately. If you haven't allowed an animal or nature to "acquire" you, the journey through yourself will take a little longer. Either way, this journey is the only one worth taking.

—SHIRLEY MacLAINE, *Out on a Leash*

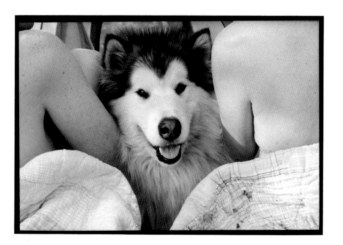

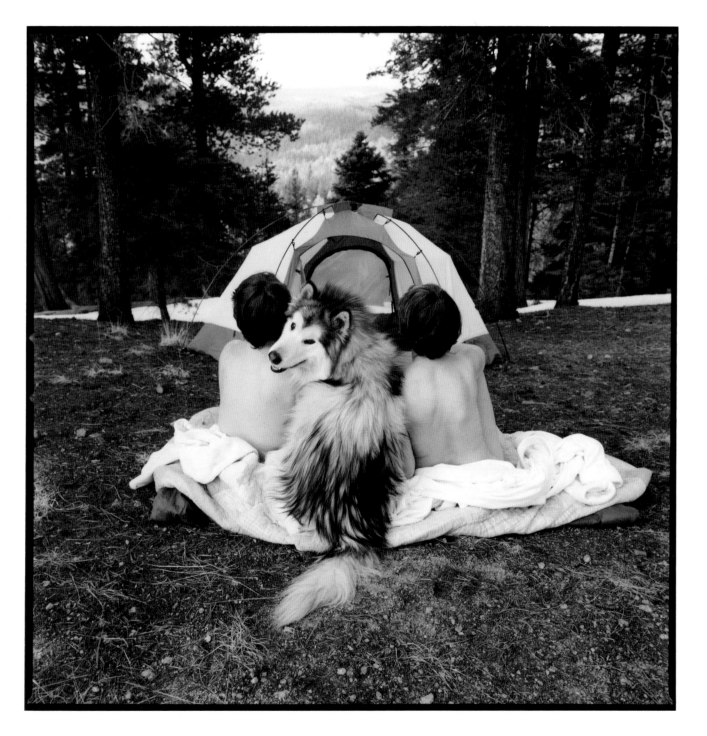

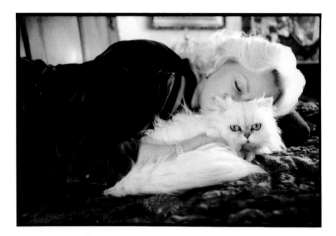

SNOWFLAKE & FELENE *with* GINGER HYLAND

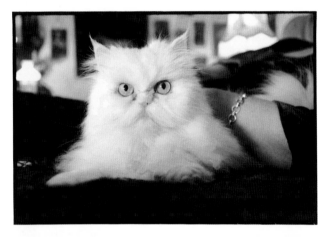

Often when I am away I miss the cats in my bed. In spite of their occasional restlessness and mine, I sleep better with my cats than without. It is one of the times we are all mammals together, sharing the same experience as well as the same space. We take mutual comfort in one another's warm presence and soft breathing. Who sleeps with whom and where is of paramount importance to cats, just as it is to people. It is one of the ways they express their trust, their affection, their bonding.

—MARGE PIERCY, *Sleeping with Cats*

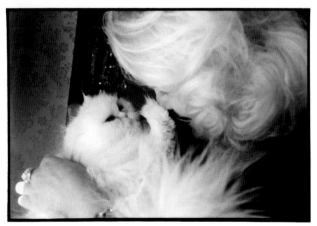

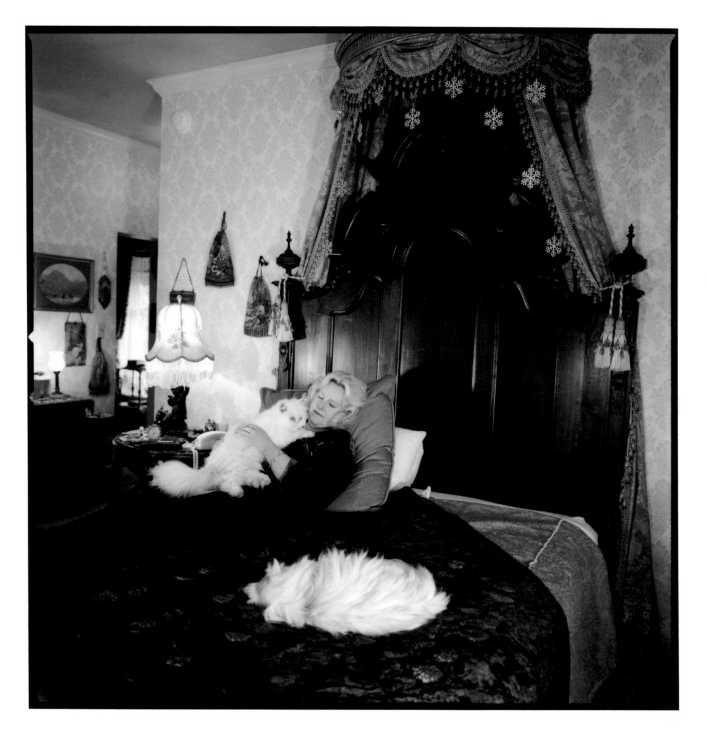

SEARCH-AND-RESCUE DOG
GUINNESS *with* LETTE BIRN

September 11th catapulted search-and-rescue dogs—and their intrepid handlers—to the forefront of our conscious- ness and placed them in a new setting of twisted metal and choking dust. In those still-hopeful days immediately after the tragedy, the dogs became a clear symbol of our hope and our determination. Most of us heard the stories about how, when the rescue workers heard the call, "Dog coming through," the crowds parted instantly to let them pass. Uni- versally, we knew they were our first line of hope in finding anyone still alive.

Before and after. All our lives are now forever divided into two segments—before September 11th, and after.

—ARDA, *Search and Rescue Dogs: Training the Canine Hero*

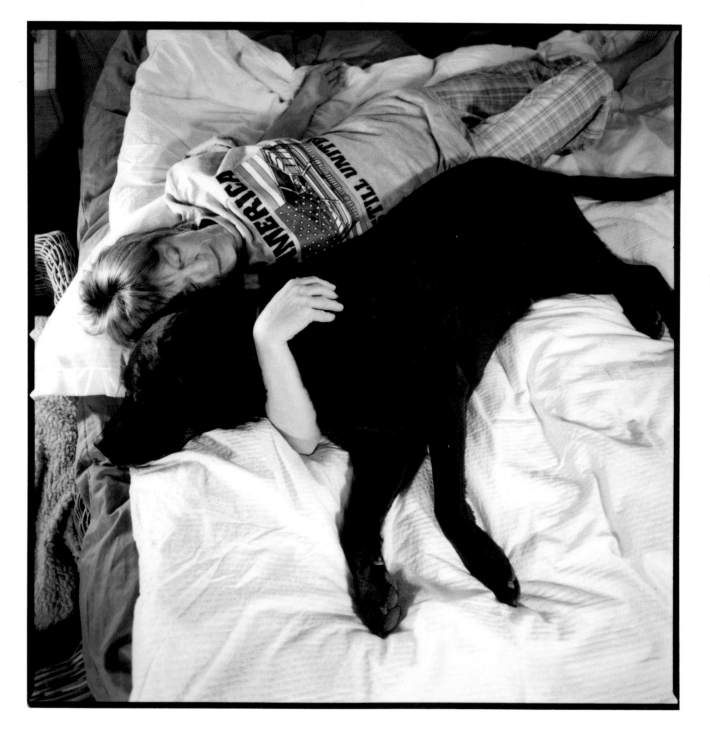

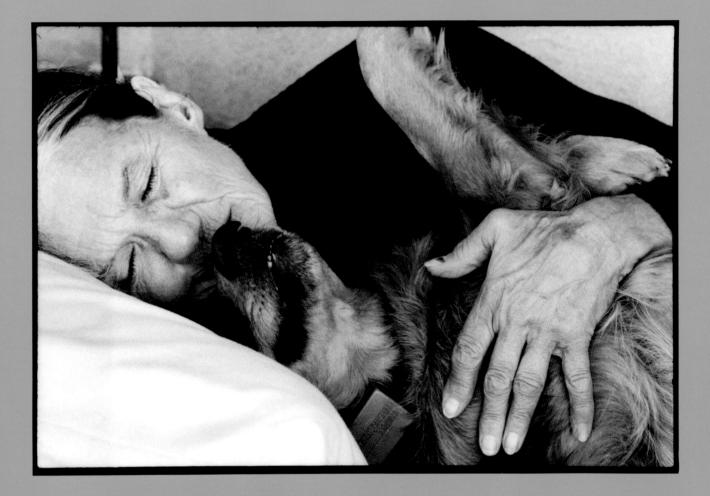

THE STORIES BEHIND THE PHOTOS

1 SOPHIE WITH MICKEY FINEBERG

Sophie was my mother's joy. And my mother was Sophie's. Mickey's reward after a long day at work was an ecstatic little Chihuahua spinning in circles of anticipation at the door. Each morning, Sophie would rise from her heating pad and attempt to awaken my mother. First, she'd stare intently at Mickey, wagging her tail. This was rarely effective. Next, she'd pick up her stuffed bear, which was only slightly smaller than she was, and drop it a few inches from my mother's face. If that didn't work, she resorted to licking Mickey's face, then steppping back, pausing, and repeating the staring/tail-wagging motif. As a final approach, Sophie would retrieve her rawhide chewy stick and attempt to poke Mickey's eye out. This was always the most successful strategy. Once awake, Mickey played with Sophie and the stuffed bear, then held her little dog very close, and whispered sweet, tender sentiments to her, before sharing a bagel and cream cheese breakfast.

2 SKUTTLE WITH TARA WERNER

Meeting Tara was like meeting Pippi Longstocking come to life! And cradled in her left arm was a beautiful white hen with a crown of feathers that crazily stuck straight up and out, like a Tina Turner wig. Start a conversation about Skuttle, a Top Hat chicken, and Tara immediately becomes ani-

mated, excited about sharing their relationship. They watch TV together—Animal Planet, the Disney Channel, and Nickelodeon—are favorites, but tend to fall asleep during the commercials. I asked why her friendship with Skuttle is so strong. Tara feels that the chicken is present for her in ways her dogs, cats, parakeet, turtle, fish and horse are not. Skuttle comforts Tara and vice versa. Tara admits, "Skuttle can just see by the look in my eye that I am upset, and she naturally comes closer and gets extra perky to cheer me up." Tara says it is definitely much easier to connect with her beloved chicken friend than most of her people friends.

3 FRANKI & DAUPHI WITH STEFFAN SOULE

I wanted to photograph someone with a full body tattoo sleeping with dogs, specifically Dalmatians. When I asked at the Four Star Tattoo parlor, the person at the desk yelled out, "This woman wants somebody with a full body tattoo who has dogs!" Everyone in the place yelled back in unison, "Steffan!" That's how I met Steffan Soule, a caretaker on the estate of Gloria and Phil Cowen. Dauphi, the Cowen's black male toy poodle, used to fly to and from New York with them. But once they got Franki, a black female standard poodle, the logistics became too complicated. Sleepovers with Steffan satisfied the problem. And the contrast of dark graphics on pale skin against black dogs satisfied me. "The designs,"

Steffan explains, "reflect my inner being and include the elements—water, air, earth, and fire. My right sleeve has earth symbols; the left depicts water; air is on my back; and when I'm finished, my left leg will have fire."

4 Jake with Henry Schuhmacher

Asking Henry to lie down on Jake bareback was actually a fairly dangerous request. It was an embodiment of complete trust that few of us ever experience, or would dare attempt. As Henry pointed out, "A lot of good horse people I respect would say I was a foolish man to attempt this. I'm trusting the horse won't move or in any way endanger me. The sudden flight of a bird, a loud noise, a dog running over—any of those could make Jake jump and there'd be nothing to keep me from hitting the ground. But there are times when I know I can just lie back and relax on Jake's broad back and it feels so good. If left alone, I could lie there on top of him for the rest of the afternoon. There's something about the outside of a horse that does something to the inside of a man. Being around a horse changes you, and I can't say that about any other animal I know. I've learned courage, how to be calm and still, and learned about a love I never knew existed."

5 Molly & Brigette with Sam Matthews

Baby Sam is my godchild. I was with him the night he came into the world. He is the son of my dear friend, Pam. She explained that her dogs, already nearly ten and thirteen when Sam was born, became very depressed when the new baby came home. Molly was curious but Brigette wanted nothing to do with him. "I've always been incredibly touched by the profound way my dogs have taken care of me. They've

been through so many changes with me, but this was completely different. They lost their place in the pecking order, Pam explained." Now that Sam is a little older, I asked her how they respond to one another. "Slowly they're developing a rapport. The photo says it all. Sam and the girls are sleeping together, but they're not in a big pile. The dogs understand that this is my child and, for that reason, they would protect him. But there's still a little distance between them."

6 Miss Kitty with Colleen Kelley

I've learned more about love and respect for animals from my friend Colleen than from almost anyone else. I wanted to photograph her in her studio, because her art so gloriously reflects her deep commitment. Of her special relationship with her long-haired tabby, Colleen said, "I talk to Miss Kitty all the time. Cats definitely pick up on mentally projected images. All of the world's traditions put heart/mind at the forefront of primary communication functions, because that's where our awareness dwells. Scientific studies have now shown that there is neurological matter in the heart. James Hillman says that 'the heart thinks in images.' The deep interior world arises first as an image, then transfers to the heart, and then finally into words. That primary arising is what animals are in touch with. This is particularly true when the circuitry is filled with love, which is so often the case between a person and his or her animal."

7 Raven with Leyton Cougar

I pulled out my camera and slowly approached, hands instinctively outstretched, so the wolf could smell me. This set the tone for the next four-and-a-half hours. If I took out a

roll of film, or anything else, I let Raven smell it first, just as I do with my cats. Smell is a key sense for mammals and it seemed to put Raven at ease. So much so that he dozed peacefully just a feet from me with Leyton, who says, "You can never really know your animal unless you sleep with it. Sleeping with an animal is truly a prerequisite for training. There has to be that intimacy, that bonding." I felt safe in the presence of their connection. The only tense moment came when Leyton asked Raven to lie down with him one time too many. Raven reacted with an impatient snarl. Leyton immediately responded to the warning, and the moment passed quickly. On a scale of one to ten, the day I spent with these two extraordinary beings, was a twenty.

8 Hobbes with Whitaker Fineberg

My dear nine-year-old nephew Whitaker wants to be a dog handler. So I took him to the 128th Westminster Dog Show at Madison Square Garden in New York, where he not only displayed an astounding amount of knowledge about the different breeds, he also demonstrated perfect dog show etiquette, always asking owners if it was okay to pet their dogs. One of the high points for me was seeing Bill McFadden, long recognized as the top handler in the country. When I introduced Whitaker, Bill asked him, "What's your favorite breed?" Whitaker replied, "I like them all." Bill laughed, "Good answer. What kinds of dogs do you have?" "I have a Cairn Terrier and an English Setter." Bill's mouth dropped open. "Those are the same breeds I have!" When I took a photo of the two of them, it felt like one of those rare, goosebumpy, passing-of-the-baton moments.

9 Koi with Sharon Berkelo

When I mentioned this book project to my client, Sharon Berkelo, she suggested, "Why not come over and photograph my fish?" I wondered if she had an aquarium. "No, no. I have koi. Eighteen of them." "Okay," I said, "But you don't sleep with your fish, Sharon." "That's not completely true," she replied. "In the middle of the pond is a large, flat rock where my husband and I hang out with them." I wasn't convinced; I mean, they're fish. They don't have names. Where's the personal connection? "Oh, they all have names," said Sharon. There's Fred Friendly, and Shelley, a red koi named for Sharon's sister, who is a redhead. And there's Heidi, who got her name because she's shy and tends to hide. And Tux and Edo, who came as a pair. "We greet each one by name when we feed them. Fred is the alpha fish. He's the first one to greet us. When Fred hears the sliding door open he immediately comes to the surface, and the rest follow."

10 Shannon with John Wallace

My dear friend John is a sensitive, profoundly gentle man, with a deep desire to serve the planet. He leads seminars in a ceremonial kiva in which he challenges participants to live life passionately and align how they spend their time, energy, and money with personal accountability. John feels that animals, both wild and domestic, are part of our genetic landscape. He says of Shannon, his Australian shepherd, and my good friend, "She's my partner. We listen to and communicate with each other. I watch her; she pays attention to my lead. We're mutually respectful. Our relationship is not about dominion over." Shannon is, first and last, a herding dog,

and instinctively assists John with his seminars. If, as often happens, a participant becomes emotional, Shannon will lie in his or her lap. She senses when and how to be present with different people because she knows how to track and respond to different kinds of energy.

11 Exotic Birds & Dog with Pat Wright

The first thing Pat said when I arrived for the shoot was, "I hate to have my picture taken. I'm doing this only because I want my birds to be shown off. I love them *that* much!" And there was no way I could miss her devotion to them—their animated exchanges were a joy to witness. Pat confided that from the age of four she had a recurrent dream of flying. She would look up at the sky and feel her body soaring across her front lawn. It wasn't until she was nineteen when Pat met her first bird, a friend's parakeet. It was immediate love. Prior to that moment, she thought birds were just creatures that sat in cages looking decorative. When I asked Pat how her birds affected her, she said: "People simply don't know who I am until they come to my house and see me with my animals. *This* is Pat. They define the person that I am. You know, Jill, I just don't get people who don't love animals. I can't relate to them at all."

12 Simon, Red & Be with Laura Bassett

I've known Laura since she was eight years old. When I asked what animals meant to her, she couldn't stop crying. After the tears abated, she collected herself and was able to answer: "For someone like me, recovering from old wounds, it's the consistency animals bring. One of my greatest joys is waking up in the morning, my favorite time of day, and we're all together. We're happy to connect with each other—the

dog and the cats—we're happy to have each other. Ironically, I love the responsibility of being their mom. I never had that consistency as a child. It always seemed that our parents were burdened by us. My responsibility as the oldest child and sometime-mother to my younger siblings often drained me. But my responsibility to my animals is a joy. Even when it's challenging, if one of them gets sick or they're not getting along or one of them is in a bad mood, I love the simple joy of knowing they need me."

13 Samoset & Izabel with Georgia Evans

The day I went to visit Amanda Evans of Sagebrush Alpacas, lured by the promise of babies, I wasn't disappointed. Four-day-old Samoset and thirteen-day-old Izabel stayed close to their mothers, who were amazingly tolerant of Georgia, Amanda's eight-year-old daughter. For these very new, young animals (they made a sweet, humming sound) and their moms to trust her as they did amazed me. Amanda explained that Georgia and her brother Sam not only help with the feeding and cleaning, they've helped birth some of the babies. They also halter-train the baby alpacas. Amanda admitted that the kids were better at this than adults because alpacas, young and old, seem to prefer children. When I asked Amanda, who came from a sheep station in New Zealand, why alpacas instead of sheep? Her answer: "You only need five alpacas to start a business; with sheep you need at least a hundred and a tractor."

14 Thirteen Cats with Candra Bryson

Candra's booklet, *Cats Together: A Guide to the Social Behavior of Cats,* came out of her extensive experience living with large numbers of cats at once. With all the books about

cats, few confront the concept of a feline social life (except among lions). Cohabitating with thirteen felines tips the scale a bit, so Candra decided to share her experiences and observations. She writes: "Living with cats is not like living with dogs or children, horses, or goldfish because when you live with cats it's like living with independent adults, who, in exchange for maintaining the household, expect you to provide food, warmth, shelter, security and even, reluctantly, medicine." Candra affirmed that: "The greatest way to bond is to share your bed. We are most vulnerable when we sleep. The greatest degree of trust is given to and accepted from those with whom we share our bed. The first message in the bonding process is that trust can exist."

15 Chip with John Chisholm

John is a joy. Although serious about his life and his responsibilities, he has a wonderful sense of humor and a refreshing perspective. Born with cerebral palsy and confined to a wheelchair, John was nineteen-and-a-half and a high school senior when I met him and Chip, his yellow Lab from Assistance Dogs of the West. Thanks to a problem in the film processing, I had to re-shoot Chip and John and was so grateful for the chance to work with them again. Chip handles his tasks with such concentration and dedication. But it's the emotional support he gives that is almost incalculable. As if high school isn't hard enough for a teenager, John's physical limitations have led to many lonely times when he was deliberately left out or just felt socially invisible. Chip changed all that. "Since I got Chip, I get a lot more attention. I think people were reluctant to approach me because they didn't know how. But Chip attracts people like a magnet."

16 Luci Loo with Cynthia Petti

I had been warned to call Cynthia before approaching the property because she had a ferocious dog that would bite me. "If for some reason you can't get through on the phone," she said, "just beep the horn and I'll come out." I saw human skeletons dangling from tree limbs as I pulled up to the house and wondered: "Were these people who didn't phone first or beep their horns?" The ferocious dog turned out to be a Sharpei named Buddha who gladly accepted beef jerky treats from me. Jimi, the Petti's first monkey, is older than Luci, quite rambunctious, and has a crush on Diane Sawyer. (Who doesn't?) At the time of the shoot, Luci Loo was still a baby drinking formula. Excited by all the attention, she couldn't sit still. Several times she ran up my hair and started grooming my head. And at one point she grabbed one of my expensive lenses and ran across the room with her prize, screeching with delight.

17 Noodle & Bee with Jane Farrar

Borzois are the most peaceful, stately, and ethereal of dogs. They seem to be *in* the world but not *of* it. I could tell by the way Jane wrapped herself around her dogs when she lay down with them that she was matching pieces of the same puzzle. "One of the most life-affirming things we can do as humans is connect to animals," Jane explained. "There are a lot things we're not doing well, politically and culturally, but this is one way we *can* do some good. Actually, I *need* animals," Jane continued. "My life feels right when there are animals in it. When they're not, it feels strange. Some people find a sense of peace with God and nature; I need to connect with nature through animals. I connect with the earth first,

before people. It's just my spirituality. Relating is so important to us as human beings, although, these days it's been put on the back burner. I like to care for animals and give them respect and honor for their very being."

Faust was watching TV when four-year-old Sage Beaman came home from school, ran into the den, gathered up six-and-a-half feet of reptile, and wrapped it around his neck like a Hawaiian flower lei. I followed them and an enormous English Mastiff named Spartacus into the bedroom. *Come on, Jill. Get a grip. Even the dog doesn't mind the snake . . .* I took some shots, asking Sage to shift the boa this way or that way, until he fell asleep. Then I had to move Faust myself. I was amazed. I was actually handling this creature without fear. And he felt really good, like cool soft clay. I remembered what Sage's dad had said: "People have this idea that snakes are scary, so they won't give them a chance. But the interactions are the same as with any pet. You can snuggle with snake. You can talk to him, pet him, and hold him. For the right individual, there's a real spiritual connection with snakes." Oh yes, and love is love.

I am a proud member of the Bulldog Gym. I made these photos during Mark and Jay's (the owners) lunch break. Within moments of arrival, Atlas and Mark were snoring blissfully. Jay dozed, while Emma stood watch, protecting her pack. A few weeks later, Atlas died. I asked Jay to share his feelings. "Atlas was an alien, not from this world. He was so gifted, so aware, so sensitive and smart. He was like a little Buddha. He

104

didn't really care about food or other dogs; he only cared about us. We got him when he was seven weeks old, which is pretty young. So we took turns holding him to our chests like a baby. He was my son and the bond was extraordinary. Losing Atlas was hard. I had an umbilical cord attachment to him. There will never be another Atlas. But his death gave me the biggest lesson. The experience of loving something that much, the pain was so intense that I felt vibrantly alive. So he taught me how to live harder."

Walking around the fairgrounds, I saw a boy with a rabbit lounging contentedly in his lap, oblivious to the bustle going on around them. Their connection was obvious. Later I spotted a young girl with a beautifully soft, snowy white rabbit with unusual black markings like spattered ink drops. As luck would have it, the children turned out to be brother and sister. The minute I arrived at their home for the shoot, Josh was eager to show me how he had learned to hypnotize his bunny,

a procedure that transformed Bandit into a puddle of blissfully relaxed fur. Earlene, Josh's and Janna's mom, although severely allergic to animals, is totally supportive of her kids' love for their pets. Despite continual coughing, sneezing and throat-clearing, she seemed completely oblivious to her obvious discomfort. I, on the other hand, had to stop myself from handing her an antihistamine or my inhaler!

21 KIRBY & RUDY WITH MATT & RHODA KING

If I had to pick a breed that would be fun to shoot, it would be Bassett Hounds. I was up on a ladder shooting pictures of Rudy on the recliner with Matt, when he became so relaxed he lolled his head all the way back until all I saw through the viewfinder was a neck. I raced down the ladder just in time to get the seventy-five folds of skin hanging from his jaws, his muzzle, his brows, and his ears—all draped over the arm of the chair. You couldn't even see his eyes because of the heavy folds of hanging fur. I was laughing so hard I fell back on my butt. Matt explained they had had Chesapeake Bay Retrievers and had been thinking about getting Wired-haired Pointers. But with these Bassett Hounds, they knew they would never go back to any other breed. Matt said, "Of all the dogs I've slept with, there's nothing more cuddly than sleeping with a Bassett. "Even if I wake up with a butt in my face, there's nothing more endearing."

22 BABY GIRL, LITTLE GIRL & OTHERS WITH MARK MEYERS

Mark greeted me at the gate, wearing a t-shirt with this quote: *The ass you save may be your own.* I liked him immediately. Mark enlightened me about the plight of this misunderstood animal: "Donkeys are conscientious, thinking animals. They're not stupid, the way they're so often portrayed. It's just that when you ask a donkey to do something it doesn't want to do, unlike a horse, the donkey won't do it. So the donkey gets a beating." When a donkey is rescued, Mark will often lie down with his new ward as a way to calm, reassure, and bond with it. So he was confident there would be no problem getting the pictures I wanted. Throughout the day, I saw donkeys snuffle and lick Mark's head, nuzzle and nibble at his goatee, and interact with obvious mutual trust and love. Mark confided that he's received a lot of nicknames due to his vocation. His favorite? The Ass Whisperer.

23 MARLOWE WITH PEGGY PFEIFFER

Named for the sixteenth-century English poet, Marlowe is quite independent and Peggy has her own busy life. When they come together, the level of ease and comfort between them is very sweet. Peggy shared, "There's so much intuitive understanding between us. If I'm not feeling well he'll jump up on the bed and sit with me. He doesn't need anything; he's just there." When I asked what she'd learned from Marlowe, Peggy replied: "There's something I get from animals that's about the present moment. There's no past and no future to a cat. If he's focused on a bird, it's the bird. If it's sleep, it's sleep. If it's eating, it's eating. He's got intention about everything he does." About their relationship, Peggy says, "What is Marlowe to me? I definitely know that he calms me down. He jumps on my chest, sprawls over me, and starts purring. It's become a nightly ritual of mutual calming and support we give to each other."

24 MARY WILLIAM, HUEY & SANDY SWEETPEA WITH THEO RAVEN

Eight months of the year, Theo sleeps outdoors with her dogs. When I asked, "What do they mean to you?" A crying Theo couldn't get any words out. I said, "That's okay. I get it." When she could finally speak, she said, "They are my life; even though I've finally reached a stage in life when I could afford to take a nice trip to Italy, I *don't* want to leave my animals." Theo is devoutly religious. At mealtimes, she places three full food bowls on a low bench on her porch. Any other pack of hungry Goldens would simply devour the buffet before them, but not this group. Theo has taught them to sit patiently while she offers prayers. And they wait—with bowed heads for the "Amen." No one eats until the prayer is done. If any one jumps the gun, she starts over. The instant "Amen" leaves her lips everyone eats. Newcomers are not exempt. Each new dog must learn the ritual. About Sandy Sweetpea, Theo says, "She got the prayer thing down in two days."

25 BUTTON WITH GLORIA SHARP

Call me crazy, but I've always liked the smell of skunk. And there is a handsome fellow that frequents my birdbath. I know he's there because he trips the motion detector light whenever he comes by to drink and splash. I love watching him. He seems fearless, and totally oblivious to my gaze! I knew I needed to find someone who shared his or her life with one of these confident, cocky creatures. So I was delighted to discover not one but two households that *share* a skunk. Button was found when he was only two weeks old, by the side of the road, keeping vigil over his mother who had been

hit by a car. Now fully grown, Button spends much of the year with Bob and Cathy Anderson but winters with neighbor Gloria Sharp. Like all skunks living in domestic situations, Button has been de-scented (a simple procedure that involves snipping the scent gland). However, Button maintains all the moxie of his wild brethren with the attitude of a supermodel.

26 BELLA WITH DEWITT BOLDEN

Bella could have been a show dog. But this dog made a clear choice to be with DeWitt—which sometimes requires six to eight hours of meditation a day. Unlike other dogs, Bella's not interested in retrieving toys. She retrieves souls. And DeWitt Bolden, who lives at Upaya Zen Center, is on her list. "People come to meditation retreats for many reasons. When they come seeking refuge, she knows exactly what to do, whom to approach, when to respond. If someone isn't centered in his integrity, she won't pay attention to him. She helps keep me centered in my integrity—to not be in ego—to face myself. She's a great teacher. People are her work. Her vocation. I can just hug this dog and the love that pours from her is amazing. If it's possible for ascended masters to return as bodhisattvas, I can't truthfully tell you she hasn't done this. Bella's already a master."

27 JAVA WITH DEAN HARRISON & H.G. SAGINAW WITH PRAYERI HARRISON

Because the Harrisons have hand-reared many of their big cats, bottle-feeding and sleeping with them from birth, I naively assumed it would be safe to photograph Dean and Prayeri lying down with fully grown animals. After all, lions and tigers look and behave so much like domestic kitties,

just much, *much* larger. And like many people, I believed the intimate bonds established in cubhood would simply continue forever, unchanged and unchallenged. Dean set me straight right away: "If you've only photographed domestic animals until today, you've not been at the top of the predator heap. Now you're making the leap to wild. And make no mistake, it's going to be dangerous for us—and for you." This was hunter/prey, predator/victim. It was that black and white. I couldn't ask, "Would you move his paw over to the right a little?" Dean said, "You'll have one shot, Jill." I got the shot (one of each) but it was one of the most frightening experiences of my life.

28 Roxie, Martha & Buster with Carter Howell

In addition to the three gorgeous, uncooperative Newfies, there were too many people and too much chaos at the shoot. Until the oldest Howell child, Carter walked over to the dogs and sat on the grass. Everyone—dogs and people—relaxed and the shoot went like a dream. Before I left, I said to Carter, "It's an incredible gift when a human being can be of such comfort to an animal; you have that effect on your dogs. It's a real blessing. I want to thank you because it's wonderful to be in the presence of someone who has this type of communion with animals." I didn't realize Carter's father Phil was standing behind me. He called me later to share: "When you talked to my son that way, it made me cry." Phil is loud and outspoken by his own admission; Carter tends to be quiet and contemplative. Phil admitted he often judges Carter by his own standards. But from now on he would regard his son with more understanding.

29 Siva with Nanette LaShay

I knew a *few* things about ferrets: They don't seem to aggravate allergies in people; they sleep nineteen hours a day; they do a little ferret dance on their hind legs when they're very excited; and when they're upset, they hiss. Nanette had grown up on a ranch and loved animals but suffered with severe allergies. And she worked very long hours as a surgeon so had little time for a more wakeful pet. Siva and Nanette were made for each other. "At this point in my life," Nanette shared, "Siva is the only relationship I have. I have no family, no kids, no husband. She's my home base. During my residency, I was gone every third day, sometimes for thirty-six hours straight. I was so glad to get home to her." Siva doesn't often get to go outside, so it was very exciting for her to be outdoors for the shoot. (Had a stranger not been present, I'm sure she would have done her ferret dance.) And it seemed only too appropriate that Siva and Dr. LaShay live on Possum Lane.

30 Four Cats & Four Dogs with Dawn & Paul Bick

For years I had heard about a very special couple who run a wonderful cat kennel up on Tano Road. When I finally met them, Paul described himself as a dog person and Dawn as a cat person. But in bed, with their four dogs and four cats, it's the opposite. All the dogs go to Dawn's side and the cats move to Paul's. Because the dogs are bigger, I asked how they managed. "When we go to bed," said Dawn, "everyone chooses a spot. If I get up for any reason in the night, I lose my place. It's that simple." I asked if they had planned on having eight animals. "No, we never intended that. They're all

foundlings. We've never purchased a pet. They've all been rescued. We both grew up with animals. They're our friends. And it's how we serve, like other people care for children or the elderly. I think about what we do as a vocation, to care for the welfare of other living creatures. And they're so much fun—a constant source of amusement."

31 HAMILTON WITH NEDRA MATTEUCCI

Hamilton is the Matteucci's second pig. A mere five pounds when they brought him home, Hammy now weighs in at 125 pounds. In hot weather, he retires to his own adobe pig house. But when the temperature plummets, he moves into Nedra's bedroom, leaping on her bed with aplomb. I asked Nedra about life with Hamilton. "He's definitely been an interesting pet. You really have to learn his peculiarities because he's very picky, a creature of comfort—he likes warmth, beds, food, and to bask in the sun. Basically, he's a hedonist. He wants what he wants. And you learn to let him have his way. He owns me; I don't own him." Besides caring for Hamilton, Nedra Matteucci owns three major art galleries in Santa Fe. She shared, "Once Hamilton ate the corner of a $15,000 painting! We had to have it restored." So did somebody buy it? "Yes, actually, the collectors who bought it said they liked the story of my pig even more than the painting."

32 DESTINY & BOGART WITH LORENZO WALLACE & RAMONA HEISE

Ramona and Renzo both work late, so the morning of the shoot they left their front door unlocked for me. I came in at 7 a.m. and kept as quiet as I could with lights and ladders and cameras and extension cords. All who were asleep—man, woman, and pug—when I arrived stayed asleep, except Bogart, the cat, who never took his eyes off me. After twenty minutes of prep, I was ready. And unable for another second to handle the fact that no one seemed to be aware of me but him, Bogart said, "Meeoow!" and smashed his paw into Ramona's face. Ramona didn't stir. The cat responded with "MEEOOOW." *Excuuuse me!* There's a woman on a ladder in the bedroom and no one seems to care!" Nobody moved. I completed the shoot, packed my equipment, crept through the house, closed the door behind me and left everyone still fast asleep—except, of course, the cat.

33 SCORPIO WITH LUCAS HARARI

My massage therapist told me she knew a seven-year-old boy who was allergic to all furry animals, but had wanted a pet desperately. After being denied a poisonous snake by his father, Lucas settled on an African scorpion, the largest variety, with a very imposing stinger (although it tends not to use it much). He named his pet Scorpio. Scorpio was the only animal I was unable to touch while photographing this book, but it was extraordinarily beautiful—a purplish-blue-black color, with a high sheen. Fortunately, Lucas's mom was willing to handle and position it for me. I asked Lucas, "What made you choose a scorpion?" He said it was inexpensive, but I knew that wasn't the reason. Very shyly he said, "It was poisonous," adding, "and it has claws!" *Aha!* So there was something mysterious and dangerous about it? "Yeah." Curious, I asked what Lucas wanted to be when he grew up. "Well, I'm thinking maybe CIA."

108

34 FREDERIC, BENSON & TALLIE WITH JIM LACHEY

I was driving in town when I noticed the car ahead of me had a Dalmatian sticking its head out of the sunroof, a sheepdog taking up the whole back seat, and a tiny white fluff ball standing on the driver's arm with its face out the window—three entirely different breeds. I started waving, blinking my headlights, and beeping my horn to get the driver's attention. He finally pulled over and I ran up to him, "Hi. My name is Jill. Are these your animals? Do you sleep with them?" After breathless introductions, I arranged to photograph Jim with his rainbow tribe. He later told me, "These dogs are my whole life. They have different personalities, and as they've gotten older, they've grown into amazing individuals." In Jim's first (human) relationship, he didn't have animals because his partner required more attention. Now, he says, "I'm not interested in being without an animal. Without a person is okay, but never, never without an animal."

35 GROVER WITH BOB ANDERSON

One summer night I awakened abruptly with the undeniable feeling of being watched. Glancing out my window, I saw twelve eyes gleaming back at me: four baby raccoons and their parents were lined up along a wall. I sat up in bed and began telling them how beautiful they looked. The little ones squealed and the parents lumbered away, children in tow behind them. Raccoons immediately became my latest greatest animal to love. And I'm not alone. Bob said, "We have a raccoon that's just like a dog for us. The first time I picked him up, he rolled over and I said, 'Roll me over, Grover.' So I named him Grover." Grover was discovered on Main Street in Bloomfield, New Mexico, climbing on people, begging, clowning, and generally stopping traffic. It was obvious he had been someone's pet and had gotten loose. Bob took him home (temporarily) to his wife Cathy. Where Grover has lived ever since.

36 EMILY WITH MARY LOU COOK

Mary Lou found Emily through a Want Ad. The cat had been cooped up in a trailer with other animals that were persecuting her. Consequently, poor Emily was nervous, fearful, and mistrustful. But Mary Lou reassured me, "Now, this is the gentlest cat I've ever been around in my life. She never asks for meals; she just sits quietly and patiently. She's the most peaceful cat I've ever seen." Given Mary Lou's commitment to peace (she founded the New Mexico Department of Peace Initiative and is known for her on-going interest in the *Course in Miracles* and the Foundation for Inner Peace) it makes total sense that Emily and Mary Lou found each other. Mary Lou agreed, "It's fitting I have the most peaceful cat living in a house devoted to peace. She's a quiet presence and my daily reminder of unconditional love. She just lives in joy, lives in the moment, and is the perfect embodiment of inner peace."

37 EPIC WITH ALLEN EAVES

I've always been struck by homeless people with dogs—touched by how companionship is so important—even when it's a struggle just to feed themselves, never mind a pet. I wanted to know Allen's story. "I chose to come out on the street when I was seventeen. Most homeless people, except

for the crazier ones, are out here by choice. This is where I learned to be who I am. I am who I am because I've abandoned conventional security." Allen has had Epic since she was five months old. "I don't have anyone to fall back on, because no one really wants to be friends with a homeless person." Allen spoke eloquently, "My lifestyle is physically demanding. I can be out in the elements for days and days. Epic is the key to my strength. Epic is my friend and companion. I talk to her and keep myself accountable to her when no one else is paying attention. She's my blanket and my pillow. She protects me.

110

38 Faust with Rick Beaman

When I walked into Rick's house, I found myself nervously checking the floor for something slithering around. Rick said casually, "He's in the bathroom taking a shower." What do you mean? "Go look." I went into the bathroom and very, very carefully slid open the shower door. There, indeed, was a six-and-a-half-foot-long boa constrictor, head swaying, luxuriating in the spray. I closed the door and took a breath. *Okay. I can do this.* A few minutes later Rick carried Faust out of the bathroom, wrapped in a towel. "People are afraid of snakes because they think they're supposed to be." He quickly pulled the snake through the towel to dry it before plopping him down on the coffee table. I volunteered, "I don't quite get the snake thing. They don't seem connected to you." "Oh you're really wrong about that." Rick smiled. "Loving your snake is no different than loving your dog. Love is love."

39 Edison with Ariel Freilich

Ariel is one of those rare fourteen-year-olds who give me hope for the future. She is the youngster in an alternative Jewish congregation, and never have I met more light packed into such an intelligent, articulate, attractive, athletic, able package. Rabbi Drucker mentioned to me that Ariel had aspirations to become both a vet and a rabbi. During the shoot with her guinea pig Edison, an eleventh birthday surprise from her parents, I wondered how being a vet and being a rabbi would fit together. Ariel said, "It would be hard to devote my life to both. I guess I'll have to choose one or the other. Being a vet, there would be new animals all the time. I'd like the variety. Being a rabbi, I'd have to study and read a lot. I like that too." Her biggest concern? She claims to be a terrible speller. I have no doubt this young woman will sort it all out, and creatively combine her love for animals with her love for Judaism. As to the other, well, that's why there's spell check.

40 Archie & Biscuit with Rebecca Fitzgerald

Some of the subjects who appear in this book worried about looking disheveled because they were, after all, in bed. Some had to have their hair just perfect and were unwilling to look frumpy or frowsy or mussed up. (Mostly, I'm talking about the humans, but there were a few cats that . . .) Rebecca and her Jack Russells were three of my more down-to-earth models who were willing to look like they had just gotten up—because they had! Rebecca asserted, "I wanted a real companion that was personable and spunky. Spunk is a requirement in my life. I want animals that are fun. I live alone so my dogs have to be good company, and, boy, are they ever! They're an absolute scream. Without them, life would be too quiet and way more

organized. They add a zest and spontaneity that's delightful. And they get into the very best kind of trouble. I've always had great affection for the rascal and the rogue."

41 Goji with Nancy Stokes

While in Nepal many years ago, I got very ill. I was alone, frightened, unable to breathe, and unable to get a flight out of the country. As I lay in bed, my only companion was a tiny gecko clinging to a corner of the ceiling. I worried it would drop down into bed with me in the night. But it stayed put, making no demands, merely offering its calming green presence. So when I met Nancy and asked her, "Why a gecko?" it was more of a rhetorical question. "Geckos are sensitive and can be quite emotional." Nancy tried at one point to find a partner for Goji, but "She really prefers to be alone. We tried companionship (other geckos, Asian chubby frogs) and it was a disaster." Geckos are intelligent and (when not being set up on blind dates) have good personalities. Goji accompanies Nancy grocery shopping, and naps with her every afternoon. And Nancy thinks Goji has the cutest elbows and knees of any little being on the planet.

42 Kindred Spirits Animal Sanctuary & Elder Hospice and Ulla Pedersen

The peaceful energy of the Sanctuary is basically a reflection of Ulla, a solid Scandinavian presence, who is like the Pied Piper to Kindred Spirit's current residents: twelve dogs, two goats, two horses, and seventy poultry. She told me, "The closeness of the sleeping state is so therapeutic. With our culture in general, whom we let into our beds is a big issue. Sleep is a time when an animal may feel my vulnerability,

and vice versa; it is a shared experience. It is in this space when it is safe for the previously injured or abandoned animal to connect. I also work with prayer and intention." After a thoughtful pause, she continued, "It comforts me to know that none of these animals will die alone. They will die surrounded by love and a sense of thankfulness for having been with us for a time." Ulla says she's been very lucky, that each animal in her care, when it was their time to go, has given her a sign that they were ready.

43 Scott with Sarah Williams

I got to the Equestrian Center early to be meet Scott, a handsome gray thoroughbred. "Now Scott, are you going to behave and lie down with Sarah?" Scott whinnied loudly, looked me directly in the eye, got down onto the floor of his stall, rolled onto his back, and lay there perfectly still. "Great!" I said, in my most equinely encouraging voice. And the second I said it, he got up and swiveled his head around with a look that clearly communicated: "I certainly won't be doing *that* again." Sarah explained later, "That's why I call

him Snotty Scotty, because he's got this attitude." But when I arrived again early the next morning, I think Scott sensed that if he didn't cooperate, I'd be back every day until he did, understanding that I wasn't going anywhere until I got the shots I wanted. His obvious love for and trust in Sarah also probably affected his attitude change, and Scott behaved like the gentlemanly aristocrat that he is.

44 Sabrina & Ray Ray with Betty Kyle

This was one of those times when I had to be interviewed by a dog prior to a shoot. Ray Ray had lost her previous owner in a sad and traumatic way and was extremely shy and nervous around new people. I had known Betty for years and knew of her special rapport with rescued greyhounds, in fact, any animal in need. Even for Betty, Ray Ray's insecurity proved to be a challenge. It took Betty years to win Ray Ray's confidence and calm her down. But once won, it was worth all the effort and patience. Ray Ray's love is forever. To my relief and delight, I passed the Ray Ray test, and spent a lovely afternoon playing and bonding with her and her companion Sabrina. There's nothing quite as gratifying as having an animal trust you—especially one that has been hurt or heartbroken. So I was deeply touched that Ray Ray remembered me fondly when I returned a few weeks later for the shoot.

45 Black Snow with Eliza & Rafael McLeod

Rafael and Eliza's dad, John, chose to raise his adopted children on a ranch because, "Work is play to young children. At ages twelve and eight, they already drive trucks and tractors, move bales of hay, chainsaw wood, and help build fences."

About the kids in relation to animals, John says: "Their participation on the ranch has given my kids a sense of self-worth and identity. The cycles of birth and life and death have been a big part of their growing up from the beginning. We have dogs, cats, chickens, turkeys, goats, rabbits, ducks, goldfish, horses, and a bird." When I asked Rafael what he liked best about living on the farm, he said, "There's not a lot of noise. It's quiet and peaceful." And what does Eliza enjoy most about ranch life? "There's not as much pollution as in town. You can run and go hiking. You learn how to make a garden. And you learn how to take care of animals. You can't have a lot of animals if you live in town."

46 Molly with Ashisha & Carolyn Lake

Years after Ashisha lost Cheska, the perfect malamute, she and Carolyn chose Molly. Molly, however, is nothing like Cheska. What they didn't know until recently is that Molly's father was in part a genetically wild dog, and Molly shares at least some of his genetic make-up. Like a couple raising a child, Ashisha and Carolyn have had to learn to respect each other's differences in how to raise Molly. They even wondered if they should keep her, as Molly's behavior with other dogs became more of a problem. "We've finally come to the realization that Molly's not aggressive, she's just a bully having a great time. If you had a child and that child was difficult, you wouldn't give that child away, would you?" Up on that mountain away from the rest of the world and its dogs, alone with her pack of people, Molly seemed to relax. Utterly delighted with herself, she couldn't have been a more delightful companion.

Ginger's complete and unwavering commitment to animals started practically from the moment she popped out of the womb. By the time she moved to Santa Fe in 2000 from her ranch in California, it took less than six months for her to become indispensable to many organizations that populate our animal-friendly city. She's Vice President of the Board and President of the Capitol Campaign for the new Shelter, and she's already participated in three charitable Barkin' Ball fundraisers, and headed both the Woofstock and Feline Follies. Says Ginger, "I have to be with animals. It's part of the package. Animals come with me. They're family. If anyone is going to be in my life, they have to accept my animals." The kitties follow her everywhere, careful not to disturb her collection of crowns and tiaras, because, according to Ginger, "They already think they're queenly enough."

Guinness is an eleven-year-old male Black Labrador who is certified in wilderness and urban search-and-rescue and search-and-recovery. Guinness and his partner Lette were one of many heroic teams called to the Pentagon after 9/11. I had heard about other rescue workers on the scene who asked to take Guinness for a walk or even just sit with him, so comforting and restorative was his presence. According to Lette, "Guinness had unending requests." I also heard that some 9/11 dogs had suffered from depression. Lette explained, "That's not strictly true. What you have to understand is that some dogs are trained to find living people, and some, like Guinness, are trained to find both the living and the dead. If a dog is trained to rescue only live people and all he's recovering are cadavers, he will get depressed. It is an emotional response to failing at the task for which he's been trained."

113

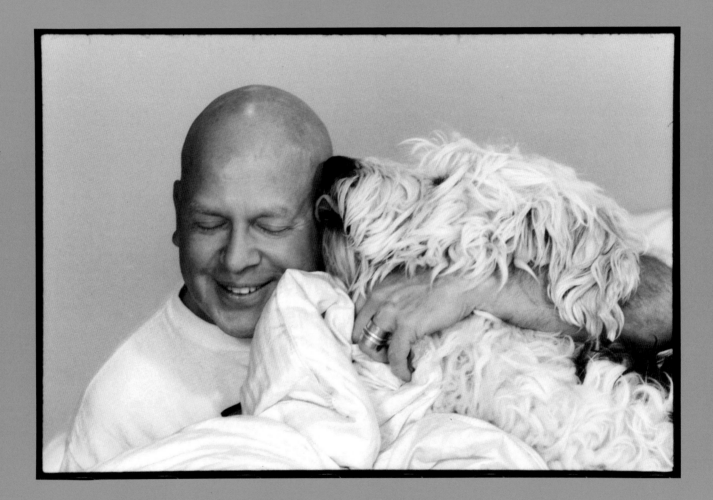

HEALTH BENEFITS OF
THE HUMAN-ANIMAL BOND

poem #49

prescription: dog: take one three times a day

for a walk in the park. take four. take five

or six. take whatever it takes to keep you alive

and out of trouble. leash up the cat on your way

out the door. the gerbil, the parrot. and hey!

don't forget the tropical fish: they can save

your life as quick as the rabbit, which you can shove

under your jacket while stowing the white mice away

in your pockets. with the hamster under your hat

and the duck tucked under your arm, you're all set

for the worst the world can do, ready to go forth

with all the protection you need. why, no one can see

if there's even anyone there: just a mobile menagerie

strolling the park, the very picture of health.

—ALVIN GREENBERG, Why We Live with Animals

❋ ❋ ❋

From birth, I have had severe, debilitating asthma. There were no inhalers or advanced steroid drugs to offer me when I was a child, as there are now. Instead, there were many nights of panic in which I truly did not know if there would be a next breath. Then my parents heard about an old wives' tale that Chihuahuas take asthma away from sick children. They were desperate to help me and, consequently, willing to try anything. So they overcame their skepticism and, one day, my father came home with a chestnut-colored Chihuahua puppy we named Juan Jose. I don't know if it was the power of suggestion, my delight in the prospect of a puppy rather than a painful penicillin shot, the notion that *something* might help me in my struggle to breathe, or simply the companionship of Jose, but I got better. A lot better.

Animals that live with people have an amazing ability to read human body language and can pick up subtle, physical clues that tell them how their human companions are feeling—happiness, sadness, anxiety, anger. A Harvard University study demonstrated that dogs were superior to chimps and wolves at reading human body language, and new research indicates that the dog's capacity to read and communicate with people silently, through gestures and glances, is an inborn talent stemming from thousands of years of living, working, and playing with human guardians.[1]

Many organizations and educational institutions throughout the United States and the world are presently

studying the human-animal bond and the complex physical and emotional relationships we share. Cultural attitudes toward animals and their treatment have undergone a dramatic shift in the last twenty years, and that shift is a driving force for global reassessment of the important role animals play in human life.

In his book, *The Healing Power of Pets,* Dr. Marty Becker writes: "The World Health Organization defines health as: 'A state of complete physical, mental, and social well-being, and not merely the absence of disease or infirmity.' To have a life worth living, you need to connect to those around you and contribute to their lives. This is where the Bond plays such a crucial role. At a time when psychology, sociology, and politics have sucked the spontaneity out of human relations, the simplicity of our affection with pets is a model for the smaller, intimate moments that really sustain us. Without those ties that bind—the bonds of love, friendship, responsibility, and dependence—we gradually begin to wither away. It is our bonds that keep us healthy . . ."

Increasingly, many disciplines within Western medicine are accepting and sharing the belief that our relational con-

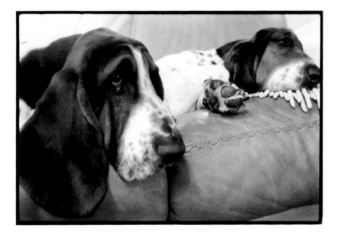

nection to our animals can actually heal us. Most of the research to date has used dogs and cats, but it is understood that *all* animal companions have the potential for positive and direct effects on our immune system. It is the chemical and psychological shift in our mind, body, and spirit that is affected, whether we are grooming a guinea pig, gazing directly into the eyes of a Golden Retriever, or petting a pet boa. As Dr. Becker has commented, "Basically we're talking about life support systems cleverly disguised as pets."

❋ ❋ ❋

If your dog is fat, you aren't getting enough exercise.

—SOURCE UNKNOWN

❋ ❋ ❋

A popular saying amongst vets is: "If you put a cat and a bunch of broken bones in the same room, the bones will heal." One researcher wondered if purring had something to do with it. Elizabeth von Muggenthaler, a bioacoustics specialist, measured the purrs of 44 felids, including cheetahs, ocelots, pumas, domestic cats, and servals. All were in the general range of 20 to 140 Hz. The average housecat comes in at about 25-50 Hz. Scientists have known for many years that vibrations at specific frequencies can induce bone growth and regeneration, increase production of natural anti-inflammatory compounds, and repair muscles, tendons and ligaments. Research shows that exposure to frequencies at that same 20-50 Hz of the housecat's purr induces increased bone density, relieves pain, and heals tendons and

muscles. And some individuals swear they can ease or completely eliminate migraine headaches simply by lying down with a purring cat next to their head.[2]

Studies show that pets have a very positive impact on various aspects of our physical health,[3] including:

- INCREASED LONGEVITY AFTER HEART ATTACKS. The odds for survival following a heart attack increase from 1 death in 15 to 1 in 87 for those who own a dog. Only 6% of non-pet owners survived at least one year after hospitalization for heart problems compared to 28% of those with pets (Friedman, 1980, 1995).

- LOWER CHOLESTEROL AND TRIGLYCERIDES. Pet owners have lower cholesterol and triglyceride levels when compared to those without pets, even when matched for weight, diet and smoking habits (Anderson, Reid & Jennings, 1992).

- DECREASED BLOOD PRESSURE AND REDUCING STRESS. Studies in women undergoing stress tests have shown that the presence of a dog lowered blood pressure more effectively than the presence of a friend. Stockbrokers with dogs or cats in their offices had smaller increases in blood pressure during stressful tasks than those without a pet present. And people with borderline hypertension had lower blood pressure on days when they took their dogs to work (Allen, K. 2001).[4]

- REDUCED MEDICAL APPOINTMENTS AND MINOR HEALTH PROBLEMS. Persons living at home with pets had fewer medical appointments and minor health problems overall. (Friedmann, 1990, Serpel, 1990). In nursing homes where companion animals became part of the therapy, the use of prescription drugs and the overall cost of patient care dropped. [In new nursing home facilities in New York, Missouri, and Texas that had animals and plants as an integral part of the environment, medication costs dropped from an average of $3.80 per patient per day to just $1.18 per patient per day (Montague, 1995).][5]

- PREDICTING SEIZURES. Some people who have periodic seizures reported that their dogs could sense the onset of a seizure. "Seizure-alert" or "seizure-response" dogs can be trained to signal their owners 15-45 minutes prior to a seizure.

- CONTROLLING "FREEZING" IN PARKINSON'S DISEASE. "Freezing" occurs when a patient's feet freeze in place while the rest of the body keeps moving, causing a fall. Helper dogs are trained to identify this condition. When the dog touches the patient's foot, the freeze is broken and the person can continue walking. How or why this works is, as yet, unknown. The dogs are also taught to counterbalance and help their humans to regain their footing after a stumble or fall.

- DIAGNOSING CANCER. A dog in Florida, named George, is reputably able to detect a scent emitted by certain skin tumors (malignant melanomas) with nearly 100% accuracy.

- INCREASED PHYSICAL ACTIVITY AND FUNCTIONING. People with pets often have better physical health due to the need to exercise and care for their pets.

For those with isolating conditions, such as Alzheimer's or AIDS, pets are a ready and willing source of companionship, physical affection, and emotional support. Animals help us feel loved and needed, and thus enhance our ability to deal with the life-altering changes that accompany devastating illness or injury. These people often receive less touch from caregivers than those with other conditions. Companion

animals help health care providers maintain a high quality of life by addressing the emotional and social needs of their patients.[6]

Emotionally, psychologically, and socially, animals[7] help us to:

- ADJUST TO SERIOUS ILLNESS AND DEATH. Children often turn to pets for comfort when a friend or family member dies or leaves the family (Raveis, 1993). Adults without a close source of human support while grieving were found to have less depression if they had a pet.

- HAVE CONSISTENCY. Caring for a pet gives us something to look forward to each day.

- HAVE MORE AND BETTER SOCIAL INTERACTIONS. Surveys have shown that 70% of families surveyed reported feeling happier after acquiring a pet (Cain, 1985). Residents at a VA hospital had more verbal interactions with each other when a dog was present. Dogs were also shown to increase socialization among Alzheimer's patients in a nursing home setting. Residents in long-term care facilities were more likely to attend activity sessions when an animal was going to be present.

- HAVE PHYSICAL CONTACT. More and more studies show how vital it is to our physical and emotional health to have someone or something to touch and pet. Some studies show stroking a cat for several minutes helps to release endorphins in the brain, producing a feeling of tranquility in pet guardians.[8]

- FEEL BETTER. In one survey, 97% of pet owners reported that their animals make them smile at least once a day, and 76% believed their pets eased their stress levels.[9]

- SLEEP BETTER. A poll by Cats Protection in the U.K. found that 44% of participants enjoyed a better night's sleep with their cat than with their human partner because cats took up less space in bed and were undemanding at bedtime, and because purring was preferable to snoring.

- LIVE BETTER. Nearly half the respondents in the same British survey said their cats were better companions than their current or past human partners, citing lack of conflict with feline friends, and noting that cats were nonjudgmental, more fun to be around, more loving, and inspired a more positive outlook on life.[10]

⌘ ⌘ ⌘

You can't look at a sleeping cat and be tense.

—JANE PAULEY

⌘ ⌘ ⌘

Karen Allen, a social psychologist, stated in her presentation to the American Heart Association, that studies conducted "indicate that [pets] offer a non-judgmental presence that influences how owners see difficult events: To have something in your life that's totally on your side has a powerful effect. Somehow their presence changes your perception of what's going on from a threat to a challenge." As scientists are quickly learning, unconditional love is very powerful. Allen adds, "Powerful enough to rival the effectiveness of some drugs prescribed to us by our doctor. Consider adopting a pet—he or she may be the only medicine you ever really need again."[11]

According to a study by Richard Avanzino, a pet can help ground psychiatric patients, even those with schizophrenia and bipolar disorder. Avanzino served as president of the San

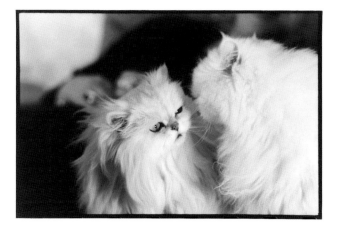

owning pets? Considering that 8% of the GDP [Gross Domestic Product] of Australia, over $30 billion, is spent on health care, their calculations indicated that the presence of pets could save between $790 million and $1.5 billion annually, depending on whether only the pet guardian or other family members were taken into account. Although more research is needed, what was clear is that the link between pet ownership and better health could have profound implications for health policy and practice.[14]

❊ ❊ ❊

There is no psychiatrist in the world like
a puppy licking your face.

—BEN WILLIAMS

❊ ❊ ❊

Francisco Society for the Prevention of Cruelty to Animals, which conducted 65 visits by animals to a locked psychiatric unit of San Francisco General Hospital over a three-year period (1984–1987). More than 45% of the patients showed improved socialization, more than 43% increased their communication, and 33% became more oriented toward reality after the visits from the shelter animals.[12]

Even passive observation of animals has been shown to reduce stress. Spending no more than ten minutes watching tropical fish swimming in an aquarium proved as effective as hypnosis in reducing the anxiety and discomfort of adult patients about to undergo dental surgery.[13]

Bruce Headey, associate professor at the University of Melbourne, and Warwick Anderson, professor at the Baker Medical Research Institute, were inspired by the *Australian National People & Pets Survey 1994* that showed that dog and cat owners make fewer doctor visits and appear to be in better health than non-pet owners. They reasoned that the presence of pets therefore entailed savings in health expenditure and posed a classic economic "what if?" question: How much money is saved in human health care costs by

Animals and children go together. From the time they're born, children wear clothing and sleep on bed linens covered with cute critters; nurseries and bedrooms are decorated with bunnies, frogs, bears, kittens and puppies, zoo and farm animals; they cuddle their stuffed animals, and play with all kinds of other animal toys. Psychiatrist Aaron Katcher reported that 94% of books used to teach young American children reading and language use animals.[15] One study indicated that children said dog and cat more than any other words except mama and daddy or their equivalents.[16] Some say dog even before they Ma![17]

Children with autism have impairments in communication and in forming social relationships. Interestingly, there are anecdotal reports of autistic kids forming close relation-

ships with animals in which they displayed behaviors toward a pet that they rarely, if ever, displayed toward humans. Despite their aversion to being touched, they evidently enjoyed the tactile comfort of animals. Pets were sought out for companionship, comfort, and confiding in ways never shown to family members. They also displayed greater sensitivity toward the needs and feelings of the animals, together with a lack of anger and aggression.[18]

❊ ❊ ❊

A dog teaches a boy fidelity, perseverance, and to turn around three times before lying down.

—ROBERT BENCHLEY

❊ ❊ ❊

According to the Fox Valley Humane Association, studies reveal that pets can raise a child's IQ scores, cognitive and social skills, as well as help that child to develop compassion and self-esteem.[19]

The Delta Society cites the following studies:[20]

- Children who own pets are more involved in activities such as sports, hobbies, clubs or chores (Melson, 1990).

- Children exposed to pets during the first year of life have a lower frequency of allergic rhinitis and asthma (Hesselmar, 1999).

- Children who had a dog present during physical exams showed lower heart rate, blood pressure and behavioral distress than when the dog was not present (Nadgengast, 1997, Baun, 1998).

- Children who own pets score significantly higher on empathy and pro-social orientation scales than non-owners (Vidovic, 1999).

- Positive self-esteem in children is enhanced by owning a pet (Bergensen, 1989).

- Contact with pets develops nurturing behavior in children who may grow to be more nurturing adults (Melson, 1990).

Caring for infants and toddlers is associated in children's minds with "women's work," but there is no such gender association when it comes to caring for pets. Thus, it is particularly useful training for the development of nurturance in boys.[21]

Literacy specialists have found that children who are below their peers in reading skills usually feel intimidated by reading aloud in front of a group, view reading in general as a chore, and have lower self-esteem across the board. The Orange County (California) chapter of the ASPCA sponsors a summer Canine Literacy Project in which students read aloud to a friendly, nonjudgmental canine audience, and has demonstrated both improved reading levels and overall increased self-confidence.[22]

ENDNOTES

1 "'Man's Best Friend': From Nature or Nurturing?" *Animal Guardian,* Winter 2003, p.16.

2 Lev G. Fedyniak, MD, *Animal Wellness,*Vol. 5, Issue 6 DrLev@IntegrativeMedicineOnline.com

3 Holly R. Frisby, DVM, "Physical and Medical Health Benefits of Pets," 2000, PetEducation.com.

4 "Healthy Reasons to have a Pet," Delta Society, www.deltasociety.org.

5 Eileen Mitchell, "Just what the doctor ordered," *San Francisco Chronicle* E12, Sept. 20, 2003.

6 Karen Allen, Ph.D. "Coping with Life Changes & Transitions: The Role of Pets & Recent Studies on How the Presence of Pets Affects People During Life Transitions," InterActions, Vol. 13, No. 3, 1995, in *Health Benefits of Animals,* (Renton, WA.: Delta Society).

7 Holly R. Frisby, DVM, MS, Veterinary Services Dept., Drs. Foster & Smith, Inc. "Psychological-Emotional & Social Benefits," Nov. 11, 2003, PetEducation.com.

8 Fox Valley Humane Association, Appleton, WI, www.foxvalleypets.org

9 David Niven, Ph.D., *The 100 Simple Secrets of Healthy People: What Scientists Have Learned and How You Can Use It.* (San Francisco, CA: Harper SanFrancisco), 2003.

10 "Want a Good Night's Sleep? Adopt a Cat!" *Best Friends Magazine* Sept/Oct 2003, p.10.

11 "Pets as a Benefit to Our Health," www.Furr-Angels.com

12 Clea Simon, *The Feline Mystique,* St. Martin's Press, 2002, p. 221.

13 Clea Simon, *The Feline Mystique,* St. Martin's Press, 2002, p. 4.

14 Bruce Headey and Warwick Anderson, "Health Cost Savings: The Impact of Pets on Australian Health Budgets," Nov. 1995, Baker Medical Research Institute and the Centre for Public Policy at the University of Melbourne. Read the study at http:// www.petnet.com.au/health/health.01.html.

15 Katcher, A. H. and Beck, A. M., "Health and Caring for Living Things" in *Animals and People Sharing the Word,* ed. Andrew Rowan, published for Tufts University, University Press of New England, 1988.

16 Katherine Nelson, "Structure and Strategy in Learning to Talk," *Monographs of the Society for Research in Child Development* 38, no. 149 (1973).

17 Dr. Jonica Newby, *The Animal Attraction: Humans and their Animal Companions,* (Sydney, Australia: ABC Books), 1997, p. 134.

18 June McNicholas & Gly M. Collis, Relationships between Young People with Autism and Their Pets," Dept. of Psychology (University of Warwick, Coventry, West Midlands, Coventry, West Midlands, UK) in *Health Benefits of Animals,* Delta Society, Renton, WA.

19 Fox Valley Humane Association, Appleton, WI, www.foxvalleypets.org

20 "Healthy Reasons to have a Pet," Delta Society, www.deltasociety.org.

21 "Fostering Inter-Connectedness with Animals and Nature: The Developmental Benefits for Children," *Health Benefits of Animals.* (Renton, WA: Delta Society), p.16.

22 "Canine Literacy Project," *Animal Guardian,* Winter 2003, p.17.

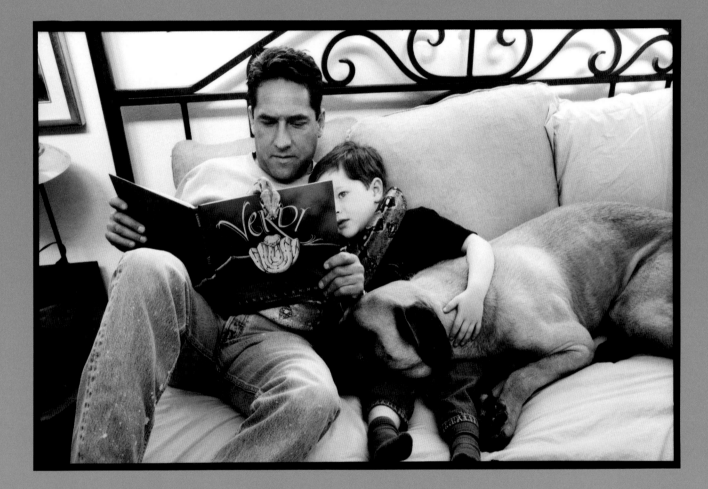

RESOURCES

During the creation of this book, I met with many remarkable individuals dedicated to offering sanctuary to animals that otherwise would have no place to go. And it was my privilege to learn about many wonderful organizations that do phenomenal work in service to animals, and thus to us all. It is my hope that they will inspire by example and encourage readers to seek out more information and get involved, either on a local or national level. This list is by no means a comprehensive one. Please forgive me if I've left out your favorite! Most of the groups represented below are 501(c)(3) nonprofits that operate on modest budgets, receive no government support, and rely almost entirely on donations, memberships, or bequests. The staff at each facility and program, small and large, is deeply devoted and compassionate—and likely overworked and underpaid for their daily heroic efforts. To readers who are moved to make contributions, your generosity will go directly to the care of the four-legged tenants and to the on-going maintenance of these very special places.

REGIONAL/SOUTHWEST

ASSISTANCE DOGS OF THE WEST

PO Box 31027
Santa Fe, NM 87594
Phone: 505-986-9748
Email: assistancedogs@aol.com
www.assistancedogsofthewest.org

The organization that referred me to Chip and John, Assistance Dogs of the West provides crucial help and companionship for people with disabilities. Some of ADW's canine candidates are rescued or donated puppies or young dogs. These animals, that might otherwise be killed, are given not only a chance to live but also to love and serve those with physical challenges. The cost per dog for the 18-month training program is $10,000, but those who need them are asked to pay a one-time fee of only $1,000, which is still often a stretch for families already burdened with extensive medical expenses.

KINDRED SPIRITS ANIMAL SANCTUARY, ELDER CARE AND HOSPICE

3749-A State Highway 14
Santa Fe, NM 87508
Phone: 505-471-5366
Email: KindredSpiritsAnimal@yahoo.com
www.kindredspiritsnm.com

Kindred Spirits provides life-long care to unwanted, older animals with special needs that would be virtually unadoptable elsewhere. Founder Ulla Pedersen and those who volunteer at the Sanctuary believe that to understand and value our aging and ailing animal friends translates directly to greater compassion for our own kind. Ulla would love to expand the facility to serve more creatures in need. Her plans include a dedicated hospice for dogs to spend their final few days in a tranquil setting that would honor their life and offer emotional support and understanding for their grieving human companions.

KRITTER GITTERS ANIMAL RESCUE AND RELOCATION

2176 37th Street
Los Alamos, NM 87544
Phone: 505-662-6806
Email: krittergitter@att.net
www.krittergitters.com

With indispensable aid from two skunks and a raccoon, Bob and Cathy Anderson run Fur and Feathers Rescue and Rehabilitation, Inc., the primary goal of which is to assist distressed or injured animals and then return them to the wild. The Andersons work closely with local Animal Control as well as Fish and Game, helping to educate exasperated residents and assisting in the safe capture and relocation of mischief-making fauna. In addition, they offer many educational programs designed to increase respect and appreciation for, as well as peaceful coexistence with wildlife.

NEW MEXICO DISASTER DOGS

11 La Rosa Court
Los Alamos, NM 87544
Phone: 505-672-1477
www.nmtf1.org

To obtain Federal Emergency Management Agency (FEMA) certification, dogs and handlers must perform highly specialized tasks in potentially dangerous and confusing environments. This requires hundreds of training hours (20-30 hours/week during the first two years), all done on a volunteer basis, with approximately $10,000 in expenses (search teams are only paid for their time during a deployment). And each team must be recertified every two years. This is a major commitment that takes intense love of the work and a strong desire to help in a crisis.

OUT OF AFRICA WILDLIFE PARK

4020 N. Cherry Road
Camp Verde, AZ 86322
Phone: 928-567-2840
www.outofafricapark.com

Founders Dean and Prayeri Harrison are completely committed to educating rather than merely entertaining the public about the majestic big cats in their care. Their focus is to help visitors separate romantic fantasy from the actual reality of living alongside wild animals. In fact, many exotic residents at Out of Africa were adopted by the Harrisons after being confiscated by Arizona Fish and Game, or after having been abandoned or donated by individuals who could no longer care for their wild "pets."

PEACEFUL VALLEY DONKEY RESCUE

PO Box 223
Acton, CA 93510
Phone: 866-DONKS 31
Email: donkeyrescue@earthlink.net
www.donkeyrescue.org

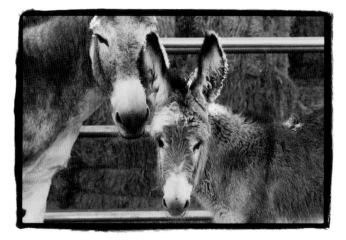

The mission: to provide a safe and loving environment for abused, neglected, and unwanted American donkeys while working to improve the plight of donkeys worldwide. Sadly, finding neglected donkeys is far too easy for Mark and Amy Meyers, as these are among the most misunderstood and mistreated animals on the planet. New arrivals come in as fast as the Meyers can respond to calls. Their hope is to pair up each rehabilitated animal with a loving, life-long human companion.

SANTA FE ANIMAL SHELTER AND HUMANE SOCIETY

PO Box 23569
Santa Fe, NM 87502
Phone: 505-983-4309
www.sfhumanesociety.org

Kate Rindy, director of the Santa Fe Animal Shelter and Human Society, told me, "The tragic reality is that there are too many animals and not enough homes for them." A third of dog owners and 15% of cat owners do not have their pets spayed or neutered, and in this group the principal reason given was that they had simply not bothered to do it, even though they claimed that pet overpopulation was an important issue to them. Preventing unplanned and unwanted litters of puppies and kittens will *dramatically* reduce the burden on public and private shelters and rescue groups.

WILD SPIRIT WOLF SANCTUARY

378 Candy Kitchen Road
HC 61 Box 28
Ramah, NM 87321 - 9601
Phone: 505-775-3304 / 505-775-3823
Email: candywlf@cia-g.com
www.inetdesign.com/-candykitchen/

Raven is one of sixty wolves at Wild Spirit Wolf Sanctuary, an organization that has rescued hundreds of wolves and wolf dogs over the past decade from well-intentioned but misguided people that try to keep them as pets. The mission of Wild Spirit is to provide a safe haven for captive-bred wolves and wolf dogs that have been displaced, abandoned or abused, and to educate the public on the needs of wild canids, the complexities of wolf dog guardianship, and the treatment of all wild, domestic, and hybrid animals. The motto at Wild Spirit is: Wild animals are not pets!

4H YOUTH DEVELOPMENT OF SANTA FE COUNTY

3229 Rodeo Road at the Fairgrounds
Santa Fe, NM 87507
Phone: 505-471-4711
Email: jhange@nmsu.edu
www.cahe.nmsu.edu/4h
(The state website has links to the national site.)

I met Skuttle and Tara Werner and ChexMix, Bandit, Janna, and Josh Groseclose at the Santa Fe County Fair, a 4H-sponsored event. 4H is the largest youth organization in the U. S.

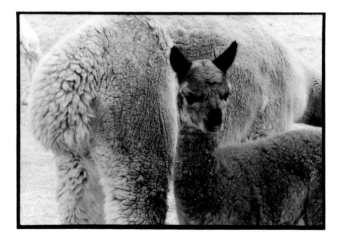

with more than 6.8 million participants. This dynamic educational program offers opportunities to develop life skills and attitudes that encourage and enable young people to become productive and self-directed contributing members of society.

NATIONAL

AMERICAN PET PRODUCTS MANUFACTURERS ASSOCIATION (APPMA)

Phone: 203-532-0000
Email: info@appma.org
www.appma.org

Founded in 1958, the APPMA is the nation's leading not-for-profit trade organization serving the interests of the pet product industry. APPMA's membership comprises more than 750 companies and businesses. APPMA supports industry-related market research, identifies and funds scientific research, and monitors and responds to legislation and government regulation.

AMERICAN SOCIETY FOR THE PREVENTION OF CRUELTY TO ANIMALS

Phone: 212-876-7700
Email: information@aspca.org
www.aspca.org

The mission of the ASPCA is to provide effective means for the prevention of cruelty to animals throughout the United States. Founded in 1866, it is the oldest and most famous among the many wonderful animal welfare organizations. The ASPCA sponsors and promotes national programs in humane education, public awareness, government advocacy, shelter support, and animal medical services and placement.

AMERICAN VETERINARY MEDICAL ASSOCIATION (AVMA)

www.avma.org

Established in 1863, the AVMA represents more than 69,000 veterinarians working in private and corporate practice, government, industry, agriculture, public health, academia, and the uniformed services. As the collective voice for its membership and for the profession, AVMA advances the science and art of veterinary medicine, offers information resources, continuing education opportunities, and quality publications.

ANIMAL PROTECTION INSTITUTE

Phone: 916-447-3085
Email: info@api4animals.org
www.api4animals.org

The mission of API's 85,000 members is to advocate for the protection of animals through legislation, litigation, and education. Over the last thirty years, API issues have included wildlife conflicts, private ownership of exotic animals, animal exploitation for entertainment, animals used in research, and treatment of animals used in agriculture. API also operates a 186-acre primate sanctuary near San Antonio, Texas.

BEST FRIENDS ANIMAL SANCTUARY

5001 Angel Canyon Road
Kanab, Utah 84741
Phone: 435-644-2001
Email: info@bestfriends.org
www.bestfriends.org

Best Friends is the nation's largest sanctuary for abused and abandoned animals. It also created the first statewide No More Homeless Pets campaign, which coordinates the efforts of its members with county shelters and animal wel-

fare groups. In addition, Best Friends sponsors many educational programs, runs a low-cost spay and neuter clinic, and maintains a wildlife rehabilitation center.

CENTER FOR THE HUMAN-ANIMAL BOND

Purdue University School of Veterinary Medicine
Phone: 765-494-0854
http://www.vet.purdue.edu/depts/vad/cae

This facility is devoted to studying the relationship between humans and animals and to providing educational, research, and service-oriented programs. The Center is concerned with all aspects of human-animal interaction and welfare, including companion animals, farmed domestic species, and wildlife. An emphasis is placed on humane ethics in managing our living resources.

DELTA SOCIETY

875 124th Avenue NE, Suite 101
Bellevue, WA 98005-2531
Phone: 425-226-7357
Email: info@deltasociety.org
www.deltasociety.org

Delta Society has been the leading force and guiding light in promoting the value of the human-animal bond on human health and well-being. It has been in the vanguard of reporting on cutting-edge research to the media and to health and human services organizations. Delta Society's many programs and resources include the National Service Dog Center, Animal-Assisted Therapy Service, and Pet Partners Program.

DORIS DAY ANIMAL LEAGUE

227 Massachusetts Ave NE / Suite 100
Washington, DC 20002 - 6094
Phone: 202-546-1761
www.ddal.org

Actress and activist Doris Day has often been quoted, saying: "The animals can't lobby Congress, and they can't vote. We can." The League focuses primarily on lobbying for legislation that increases protection for animals, while its sister organization, the Doris Day Animal Foundation, concentrates on educational programs that empower individuals to act on behalf of animals.

FUND FOR ANIMALS

Phone: 888-405-FUND
www.fund.org

Founded in 1967 by the late author and animal advocate Cleveland Amory, Fund for Animals has spearheaded some of the most significant events in the history of the animal protection movement. Continuing Amory's legacy of: "We

127

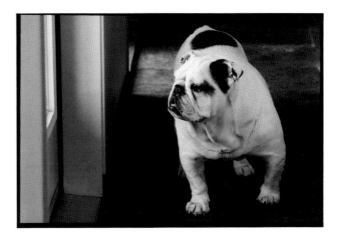

speak for those who can't" the Fund uses education, legislation, litigation, and hands-on care to protect animals from cruelty and exploitation.

LATHAM FOUNDATION FOR THE PROMOTION OF HUMANE EDUCATION

Phone: 510-521-0920
Email: info@latham.org
www.latham.org

The Foundation's mandate: To foster a deeper understanding of and sympathy with man's relations—the animals—who cannot speak for themselves; to inculcate the higher principles of humaneness upon which the unity and happiness of the world depend; to emphasize the spiritual fundamentals that lead to world friendship; to promote the child's character through an understanding of universal kinship.

PRISON PET PARTNERSHIP PROGRAM

Washington State Corrections Center for Women
PO Box 17
Gig Harbor, WA 98335
Phone: 253-858-4240
Email: ppppsd@yahoo.com or sisterop@ime.net

Begun in 1981 by Sister Pauline McQuinn, this program was the first of its kind and remains the model for the nation. To date more than 500 dogs, all from shelters or rescue groups, have been placed with families or disabled individuals, while inmate trainers have had the opportunity to rehabilitate themselves by learning valuable vocational skills including Pet Care Technician certification through the American Boarding Kennels Association.

STEVENSON COMPANION ANIMAL LIFE-CARE CENTER

College of Veterinary Medicine
Texas A&M University 4461
College Station, Texas 77843-4461
Phone: 979-845-1188
www.cvm.tamu.edu/petcare

The dream of Dr. Ned Elliot, who recognized the extraordinarily deep bond between people and their pets, the Center has been designed to provide personalized care in a home-like environment for animals that outlive their human companions. The Center's furred and feathered clients also ensure that veterinary students come out of the program not only as highly qualified vets, but as compassionate human beings as well.

VPI SKEETER FOUNDATION

P.O. Box 2344
Brea, California 92822-2344
Phone: 800-872-7387
Email: Skeeter@veterinarypetins.com
www.skeeterfoundation.org

Inspired by Skeeter, a Miniature Pinscher, Dr. Jack Stephens established the Foundation to share his belief in the positive influence of animals on human health. Endorsing the "Prescribe Pets Not Pills(tm)" philosophy, the Foundation facilitates visiting pets programs in hospitals and convalescent homes, and funds studies documenting how the human-animal bond promotes healing and recovery from illness and injury.

ACKNOWLEDGMENTS

You know how Academy Award winners make their acceptance speech and have so many people to thank the orchestra tries to interrupt them with an elongated note from the string section in hopes of drowning out their words, to be followed by an even louder long note from the horn section to get them off the stage? Fortunately, I cannot win an Oscar for this book. There would be way too many people to thank in this life, and from past lives (just ask Shirley MacLaine). And when one is expressing gratitude, being rushed is not an option.

There is always one special person that plays the-wind-beneath-the-wings role: tireless in her help, generosity of spirit, and constant support. Mine was Parvati Markus. During the making of this book, Parvati cat-sat while I went off to shoot lions and tigers and donkeys. She was my master chef, many times seen opening my back door, leaving nutritious brown rice meals in my kitchen, and quietly leaving so as not to disturb. Besides her editing skills, she also provided computer support and a face to sit across from when I needed to talk about the photo shoots and laugh or cry about what was unfolding for me. Going out to photograph or interview homeless poets, noble search-and-rescue dogs, monkeys leaping through the air, and cloistered nuns without someone to share it with and make it real, might have been too surreal. My gratefulness to Parvati is ongoing.

Grateful special thanks also to Elizabeth McLaughlin for her enthusiastic help and quality writing effort, her end-less willingness to accommodate, suggest and be involved, always with humor and compassion, and for her consistent expression of a friendship that I can depend upon and lean on; to Hal Hershey, production manager at Ten Speed Press, who remembered and appreciated the quality of my past work enough to arrange my initial meeting with the editorial department; to the City of Santa Fe, New Mexico, for the pleasure and luck of living in a town that offers so many animal appreciation events. So many people asked, "WHERE did you FIND these people?" For an extraordinarily large number of my photo shoots, the answer is right here in New Mexico.

Extra special thanks to Margot Eldridge and Gail Anderson, my two benefactor angels who offered the financial support for me to complete a dream. I could NEVER in a million years have created this book without their selfless generosity and willingness to believe in me. Their support enabled me to create without the stress of wondering if I would have enough money to finish. With their help I never compromised my goal. If your friends ever try to create an important project and need financing, and you think your large or small contribution won't make a difference, think again. It *does*. Don't hesitate to help.

Special gratitude to the amazing folks at Ten Speed Press. For a first-time author, this has been an outrageously enjoyable experience. No matter whom I worked with, in any capacity, the exchanges were a pleasure. To Kirsty Melville,

my publisher: I was lucky enough to have her say twice in an opening conversation, "We want to make you happy, Jill!" To Nancy Austin for her exquisite eye and design skills. And finally to Veronica Randall. When you are writing a book on animals, and they assign you an editor nick-named Fuzzy, you have to believe the book is destined! She was a joy to work with; her input and comments definitely shaped the final version.

Thanks to Shirley MacLaine, Ali MacGraw, Jean Houston, and Wayne Muller for their generous endorsement of my book and for taking time from their very busy schedules.

I am also grateful to Alvin Greenberg for his generosity and immediate support in contributing poem #49 for the Health Benefits section. And to Dana Standish, for allowing me to use an excerpt from her article as one of my quotes. Both are gifted writers.

Many thanks to those who supported me with their technical and professional input, most especially Alissa Marquis at F/22, master printer, who has a gift for making you feel that you are the only photographer whose work she is focusing on and who saved my ass on several occasions; Peggy Pfeiffer of Bad Dog Design; the guys at Image Maker; Maggie Lichtenberg; the crew at Visions Photo Lab; and Wendy McEahern.

A book like this involves lots of folks saying, "Oh my gawd, you *have* to contact my friend so-and-so, who has a pet this-or-that!" Thanks to those who had a hand in leading me to some of my photographic subjects: Kate Rindy, Maureen Robins, Four Star Tattoo, Jane Farrar, Darlene at Feathered Friends, Joanne at Arrighetti Animal Hospital, Kerry and Jill at Assistance Dogs of the West, Rabbi Malka Drucker, Sharon Berkelo, Rebecca Fitzgerald, Kathie Reed, Lisa Larsen, Reese at The Critters and Me, Russ at Santa Fe West-ern Adventures, and Nelda Auge of the Rio Grande Mule and Donkey Association.

Very special heartfelt thanks to my personal cheerleading squad (minus the pompoms): To my head cheerleader, Frea Rosen, who said "GO FOR IT!" when I was wondering if I should create this book after so much time had passed; and to co-head cheerleader, Mark Tamoglia, my dear brother friend who has an appalling amount of love to give, and who is one-degree of separation from anyone you'd want to know. My precious cheerleading squad: Pam Platt Matthews; Susan Corenblum Greene; Colette Baron-Reid; Caren Rothstein; Keith and Lynn; Pamela McCorduck; Ashisha; John Wallace; Colleen Kelley; my father, Sumner, and Ruth.

I am grateful to those who took their personal time and energy to help me in a variety of ways; each of their contributions was an important piece of a very large puzzle: Thomas Sharkey; Denise Kusel; Stephen Auger; Mukti Ma; Margaritte Gordon; Dee Blanco, D.V.M.; Dean and Prayeri Harrison; Marie Monteros; Charles Thibodeaux; Dr. Sonny Presnal; Dede Schuhmacher; Leyton Cougar; Mark Meyers; Kirsten Lear; Phil and Gloria Cowen; Mary Lou Randour, Ph.D.; Karen Green; Charlotte McKernan; John "Smokey" Hulbert; Jesse Salazar; Ylise Kessler; Caroline Invicta Stevenson; Sam's babysitter, Melissa; Earlene Groseclose; John Werner; Amanda Evans; Sister Marie Bernadette; Theo Raven; Joanie Kirk; Nancy Marano; and Gretchen Stephens.

Never underestimate what Lily Tomlin calls "the goose bump experience." There were some wonderfully supportive friends who would get goose bumps when I talked about my book, and cheered me on with calls and e-mails and kind words: Lorin Parrish, Gail Rieke, Althea Gray, Howard Cooper, Carole Bober, Mimi Gould, Elissa Heyman, Liz Glassman,

Francesca Steadman (special thanks for Bamboo), Jocelin Tilton, Tim Misicka, Dorothy Rogers, Virginia Hannan, Emily Garcia, Fabio, Kate McGraw, Marylyn Dorsky, Denise Anderson, and Carol Hegedus.

There are kind and concerned people in my life that fed me when I was too focused and busy to eat: Pam and Tim, Virginia and Karen, Gail and Nikki, and Mel Bucholtz— thank you all. Gathering at your dinner tables was a sweet and needed respite.

There are gifted healers and physical supports in my life that I was able to depend on during the making of this book: Maureen, for her endless patience and focused perseverance; Michael and Mark at Bulldog Gym for their innovative restructuring of my sessions according to my energy or lack of it; Bill, for helping me locate my body; and Dr. James Sussman, my asthma doctor, who was worried the making of this book might kill me since I am allergic to animals—thank you all.

To all the people who allowed me into your bedrooms and lives—thank you for the gift of your stories. Your devotion to your four-leggeds is remarkable. And to each animal I was honored to have the pleasure of being around, thank you. The relationships you maintain with your people is heartwarming and precious.

To my bodywork clients for their patience while I took time off to complete this book.

To my many friends who were there for me when I lost my sweet Miracle Maxine.

To Mr. Studmuffin and Bamboo for leaping on my photographs, pouncing on my piles, and pirouetting across my keyboard, in periodic attempts to remind me to stop working and play a while.

To my mother, Mickey, with love. I felt your presence all around me as I created this book. This one's for you.

To all my relatives, angels, guides and teachers who surrounded my daily creative effort: What a team!

And to all of you who could not wait for the book to be released so you could buy your 20 copies for holiday gifts for the animal lovers on your list —GO FOR IT! And thank you!!!

131

※ ※ ※

I can remember the first time I had to go to sleep.
Mom said, "Steven, time to go to sleep."
I said, "But I don't know how." She said, "It's real easy.
Just go down to the end of tired and hang a left."
So I went down to the end of tired and just out of curiosity
I hung a right. My mother was there, and she said,
"I thought I told you to go to sleep."

—Steven Wright

※ ※ ※

Now I adore my life
With the Bird, the abiding Leaf,
With the Fish, the questing Snail,
And the Eye altering all;
And I dance with William Blake
For love, for Love's sake.

—THEODORE ROETHKE

132

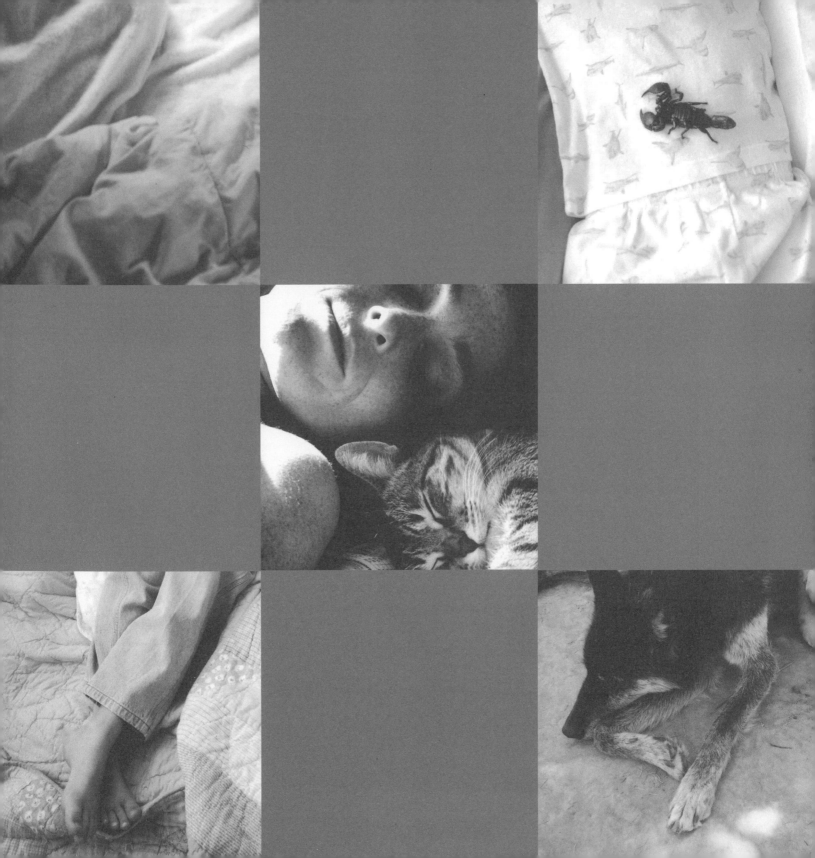

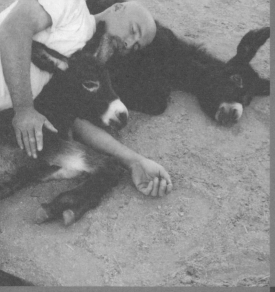
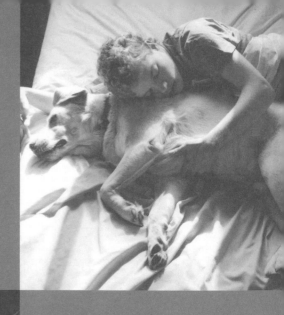
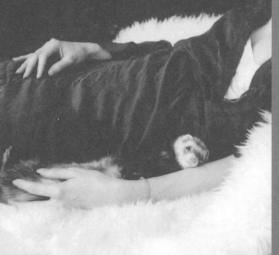